THE BEAT OF NEW YORK

A VISUAL HISTORY OF MUSIC IN THE CITY

RICHARD PANCHYK

AMERICA
THROUGH TIME®
ADDING COLOR TO AMERICAN HISTORY

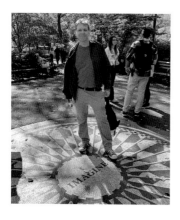

ACKNOWLEDGMENTS

Thanks to Alan for his continued interest in my book ideas. Thanks to Kena, as always, for helping transform this from manuscript to finished book. And special thanks to Kimberly for all her help and support.

IMAGE CREDITS

Library of Congress: p6, p7 top, p9-13, p15 top, p16 bottom, p18 top, p21 bottom, p22, p23 bottom, p24, p25 top, p26, p27, p28 top, p29 top, p31 top, p33 top, p34 top, p36 top, p39 bottom, p44 bottom, p50 bottom, p58 bottom.
National Archives: p14, p21 top, p40, p41, p52 top.
Smithsonian Institution: p17 top.

All other images are courtesy of the author.

America Through Time is an imprint of Fonthill Media LLC
www.through-time.com
office@through-time.com

Published by Arcadia Publishing by arrangement with Fonthill Media LLC
For all general information, please contact Arcadia Publishing:
Telephone: 843-853-2070
Fax: 843-853-0044
E-mail: sales@arcadiapublishing.com
For customer service and orders:
Toll-Free 1-888-313-2665

www.arcadiapublishing.com

First published 2023

Typeset in Trade Gothic
Printed and bound in England

INTRODUCTION

Listen and you will hear it: the beat of New York City.

It's everywhere you go! From parks to bars, from the subways to the streets, from churches to concert halls. Music in all its glorious forms, sometimes sublime and sometimes spectacular, is a vital part of city life and has been for centuries. Whether a pair of dueling drummers on 42nd Street or breakdancers in Washington Square Park, whether a mural in the Village or a memorial to John Lennon—New Yorkers celebrate their musical heritage every day in so many ways.

Though the musical styles and the musicians may have changed over the years, the passion for music has not. The city has hundreds of venues ranging from intimate tucked-away spots to massive arenas that can hold tens of thousands of spectators, hosting everyone from unknown musicians who are just starting out to chart-topping mega bands.

So many of the country's best-known musicians were either born in the city or made their way to it eventually. From the Ramones to Blondie, Bob Dylan to the Beastie Boys, New York has played a key role in the development of a wide range of musical heroes. Though their presence has never been confined to any one neighborhood, some places have had a richer and deeper musical history than others. Greenwich Village, for example, has for decades been home to many groundbreaking musicians who thrived within the creative and collaborative aura of the club-filled neighborhoods. Meanwhile, in uptown Manhattan, Harlem has been a major force in fostering the development of jazz music. Even those who didn't wind up living in New York were bound to play many gigs in the city if they had major career aspirations. The roster of famous musicians who have appeared on New York stages over the years is long and storied.

But New York is not just a place where musicians themselves live and work. It has been a mecca for songwriters, lyricists, composers, music executives, record companies, music publishers, musical instrument makers, photographers, artists, publicists, and promoters. It's also the home of Broadway, the birthplace of hundreds of famous musical plays. As of the beginning of 2023, all three of the longest-running Broadway shows in history were still playing: *Phantom of the Opera* (with nearly 14,000 performances), *Chicago* (over 10,000 performances), and *The Lion King* (nearly 10,000 performances).

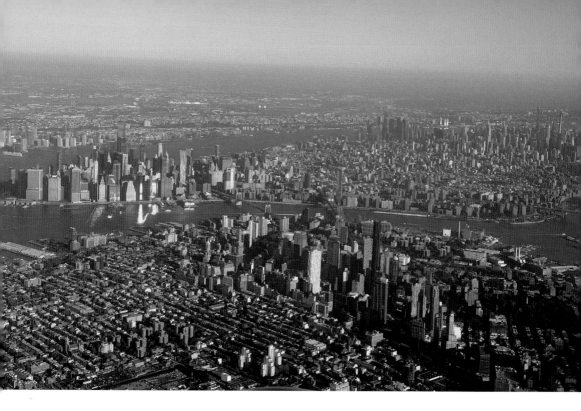

In writing this book, I visited some of the countless locations that had a role in the city's musical history. I also happened upon some impromptu musical scenes. Working on this book really opened my eyes to just how engrained music is in the very fiber of New York's existence. Not only is music everywhere, the inspiration for music is everywhere. The city and its character-filled streets and neighborhoods have inspired numerous songs, including (to name just a few): "New York, New York" (composed by John Kander and Fred Ebb, sung by Frank Sinatra), "The Lullaby of Broadway" (composed by Harry Warren and Al Dubin, sung by various artists), "Puttin' on the Ritz" (composed by Irving Berlin, sung by various artists), "Big Man on Mulberry Street" (Billy Joel), "Rockaway Beach" (The Ramones), and the "59th Street Bridge Song" (Simon and Garfunkel). The city's impact on popular music is incalculable.

It would certainly take thousands of pages to tell the full story of even one of New York's major musicians let alone the entirety of the city's musical history over the centuries; I've only got 96 pages to work with, so I've tried to make this book a broad sampling of a wide variety of musical people and places in the city, both historical and current. Though books are by nature visual rather than aural experiences, I hope that music nonetheless will jump from these pages into your head as you read about some of the musicians and songs that you know so well, or places that evoke happy memories of performances past.

Note: The images are generally presented in chronological order, either by date of the image or date of the subject of the image.

A WORD FROM GRAHAM MABY

[Recording in New York City] was just a whole different atmosphere. I mean, you have to understand something. I was 30 years old and I had never recorded outside of England so it was wildly exciting to me to be in New York, and to be cutting a record in this cool little studio in the cool part of Manhattan. Everything about it was exciting, plus we were recording with Latin percussion. I had already fallen in love with Manhattan, so I just loved being there for a sustained amount of time. We rehearsed and auditioned people, we found the percussionists that way, so I was in town for quite a few weeks and that was a very exciting recording experience.

Bass player Graham Maby on recording Joe Jackson's hit 1982 album *Night and Day* (which peaked at #4 on the *Billboard 200* album chart) at Blue Rock Studio in Soho.

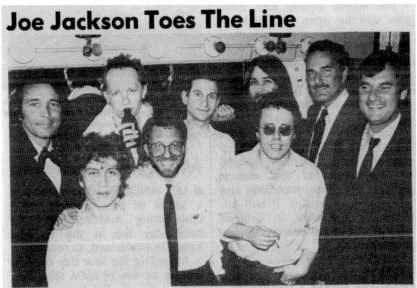

Joe Jackson Toes The Line

Shown backstage after Joe Jackson's recent performance at the Bottom Line are, from left: (front row) Gary Sanford; David Kershenbaum, producer; David Houghton; Gil Friesen, president, A&M Records; (top row) Herb Alpert, vice chairman, A&M Records; Joe Jackson; Graham Maby; John Telfer, manager; and Jerry Moss, chairman of the board, A&M Records.

A 1979 photo shows Joe Jackson and his band at the famous New York City club, The Bottom Line (West 4th Street), which hosted everyone from Carl Perkins to Barry Manilow to Cheap Trick before it closed in 2004. Says Graham Maby (top center of the image): "The Bottom Line is the top of the list" of favorite clubs he played in the city. "It wasn't actually our first gig we played, there was a couple of other clubs in Manhattan in 1979 … but I played The Bottom Line so many times after."

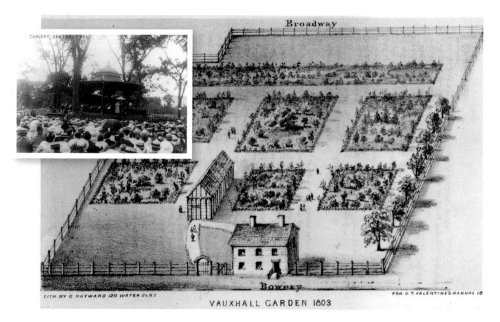

VAUXHALL GARDEN 1803

Music has been important to New York since colonial days. Vauxhall Garden was a "pleasure garden" offering refreshments and musical theater to its patrons. The establishment was first located on Greenwich Street, between 1767 and 1798. It then moved for a short time to Broome Street between the Bowery and Broadway (shown above). It relocated in 1805 to Lafayette Street. It was demolished in 1859. Inset: Concert in Central Park, 1905.

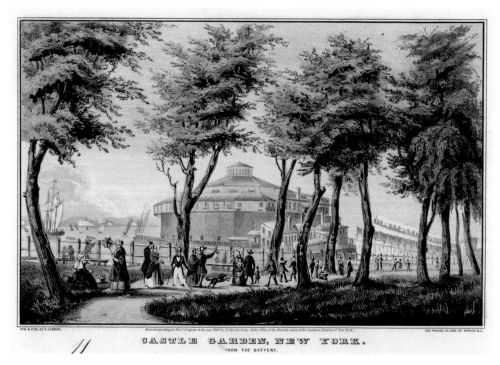

CASTLE GARDEN, NEW YORK.
FROM THE BATTERY.

Castle Clinton, a War of 1812 fort at the southern tip of Manhattan, was converted into an entertainment venue called Castle Garden in 1823. This lithograph dates to 1848.

Swedish singing sensation Jenny Lind (aka the Swedish Nightingale) went on a tour of America between 1850-52; it was arranged by showman P. T. Barnum. She appeared at Castle Garden in New York City in 1850, to the delight of the New York audience. Over 4,000 tickets were sold. This image of her performance dates to 1902.

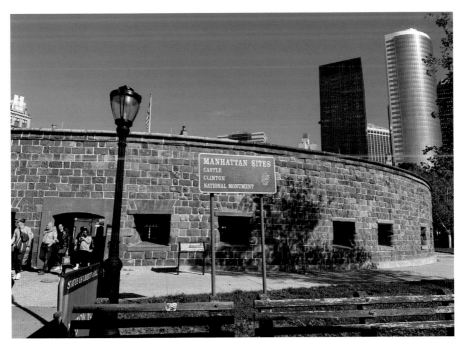

After Castle Garden's time as an entertainment venue, it was converted into an immigration facility (1855-1890). It housed the New York City Aquarium from 1896-1941. Castle Clinton today is a National Monument. Displays inside celebrate the long and diverse history of the structure that once entertained audiences.

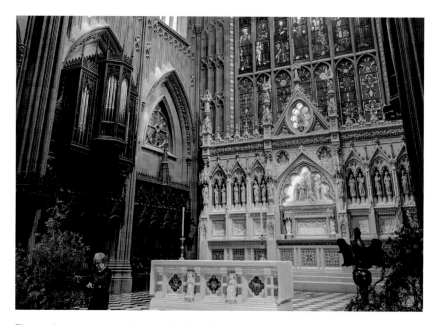

The music most consistently heard in New York over the centuries of its existence has been the organ music played in the city's churches. In the nave of Trinity Church (located on lower Broadway), architect Richard Upjohn's majestic 1846 organ case survives as the church's oldest continuous piece of furniture. When this photo was taken, a new organ was being built for the church by Glatter-Götz Orgelbau, to be completed in 2023.

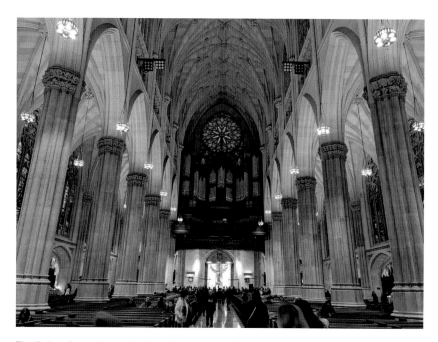

The Gallery Organ (below the Rose Window) at St. Patrick's Cathedral (completed in 1879) on Fifth Avenue, took three years to build at a price tag of $250,000 and was dedicated in February 1930. When built, it had 7,855 pipes ranging in length from 32 feet to ½ inch. As of 2022, recordings of chants are played for the thousands of visitors who come to the historic church every day. The cathedral also offers an annual concert series and an organ recital series.

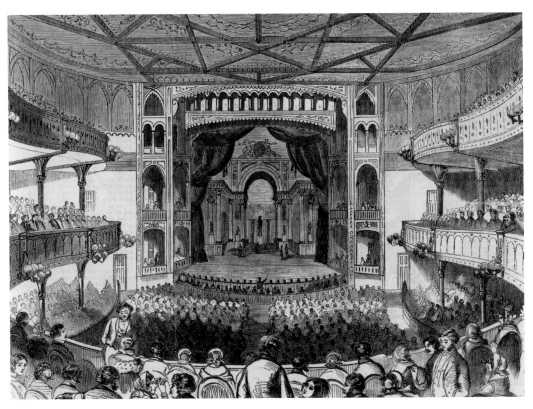

The Brooklyn Academy of Music (BAM) was founded in 1861 on Montague Street. This image shows the interior during the opening concert on January 15, 1861. The academy later moved to its current location on Lafayette Avenue. Over the years, a wide variety of musicians in all genres have performed at BAM.

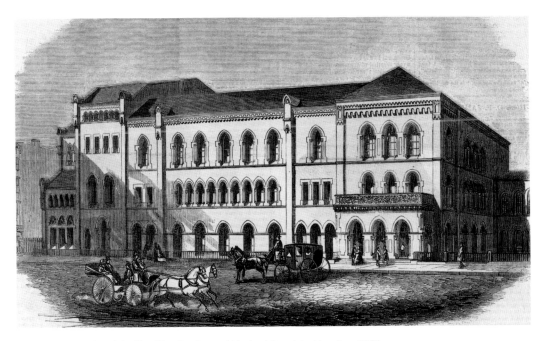

The exterior of the Brooklyn Academy of Music at its original location, 1861.

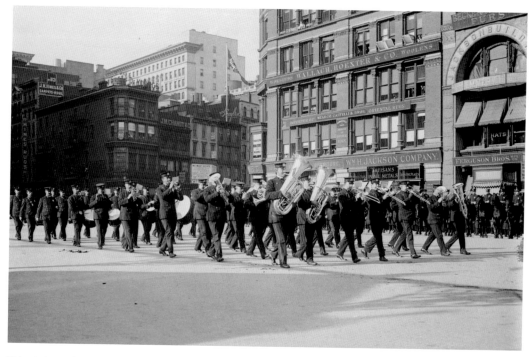

This photograph shows the New York Police Band marching in front of the Jackson Building in Union Square, c1910.

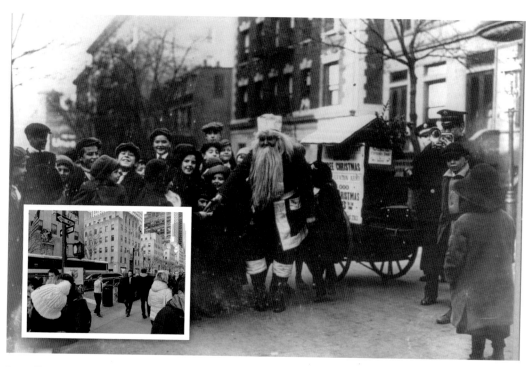

Santa Claus and Salvation Army musicians entertaining children on a New York City street in 1910. The tradition of Salvation Army musicians at Christmastime continues to this day, with numerous bellringers singing along to holiday music and soliciting donations (inset).

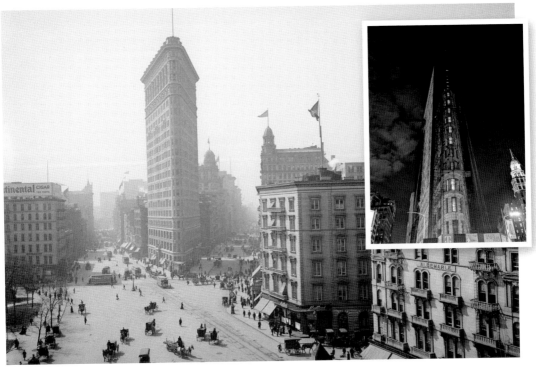

The landmark wedge-shaped Flatiron Building at 23rd Street between Fifth Avenue and Broadway was completed in 1903. In 1911, Taverne Louis, a 400-seat nightclub and restaurant, opened in its basement. It was the first club to allow black performers, thus introducing New York to the new musical style called ragtime. Composer Irving Berlin heard the music, performed by Louis Mitchell and his Southern Symphony Quintette, and was inspired to later write his hit song "Alexander's Ragtime Band." Seen here, the Flatiron Building in 1915; inset, in 2022 undergoing major renovations.

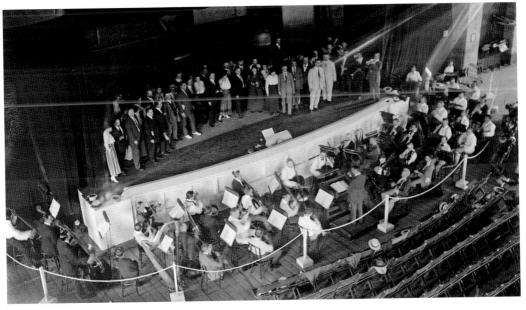

Performers on a stage and the pit orchestra during a summer opera at Columbia University, c1915.

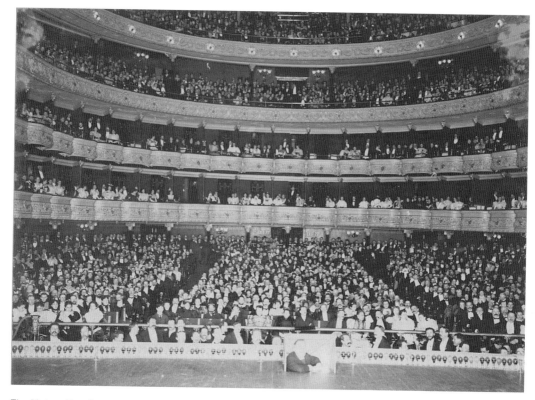

The Metropolitan Opera was founded in New York City in 1883 and was quickly among the world's top opera houses. This 1895 image shows the interior of the Metropolitan Opera House, with an audience of 3,500 people captured in a flash photograph taken by Ernest Marx on the occasion of Max Alvary's 100th appearance in Wagner's opera "Siegfried."

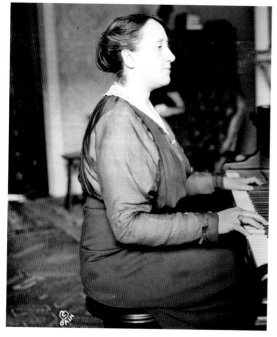

In this image, soprano Melanie Kurt poses at her piano in 1915. Kurt had come from Germany to New York to join the Metropolitan Opera that year, and was a rising star, singing the lead in such operas as *Tristan and Isolde* before America's entry into World War I forced her to leave the country in 1917. One 1916 article said of Kurt: "Probably no artist ever received greater praise from New York critics than did Mme. Kurt following her debut at the Metropolitan last season."

Attendees at the National Conference on Community Music at the Hotel Astor in New York City, May 31-June 1, 1917.

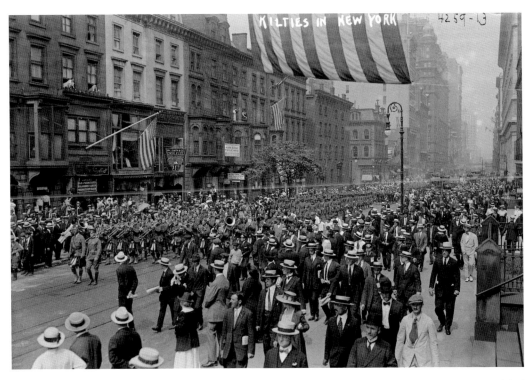

Canadian Highlander soldiers and band marching in New York City. The Highlander regiments were in the United States in July 1917 for "British Recruiting Week" which encouraged enlistment in World War I.

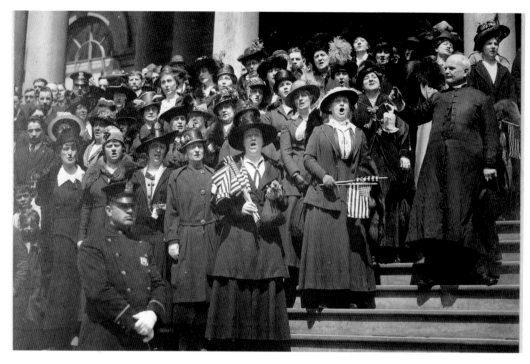

Members of the "Liberty Loan Choir" singing on the steps of City Hall, New York City, in the third Liberty Loan campaign, April 1918. At the right is Bishop William Wilkinson, who led the choir.

The Tex-Y-Quartette from Houston, Texas, sings at the opening of the Tank Corps League in New York City, February 1919. The group had performed more than 200 concerts for soldiers during World War I.

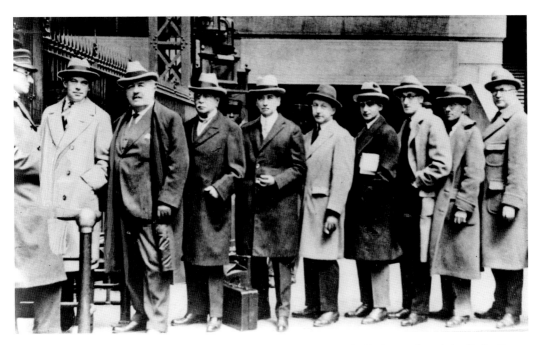

Left to right: Gene Buck, Victor Herbert, John Philip Sousa, Harry B. Smith, Jerome Kern, Irving Berlin, George W. Meyer, Irving Bibo, and Otto Harbach, 1920, Tin Pan Alley. The men in the photo were all popular NYC composers and lyricists. Smith was said to be the most prolific of all stage writers, having written 6,000 song lyrics.

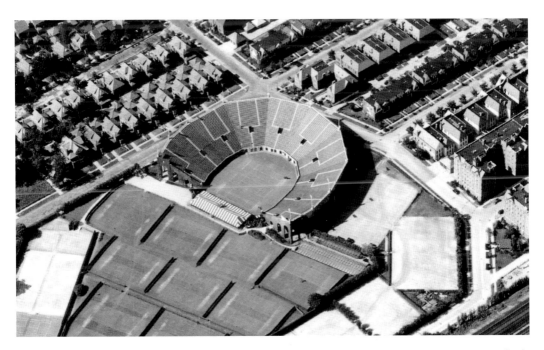

The Forest Hills Tennis Stadium in Queens was built in 1923 (seen here in 1934) to host tennis tournaments but in the 1960s began to host concerts by some of the biggest names in music, including Frank Sinatra, Bob Dylan, and the Rolling Stones. The tradition continues to this day, with a slate of major shows held there every summer. In 2019, musicians appearing at Forest Hills included Weird Al Yankovic, Elvis Costello, Sarah McLachlan, and Morrissey.

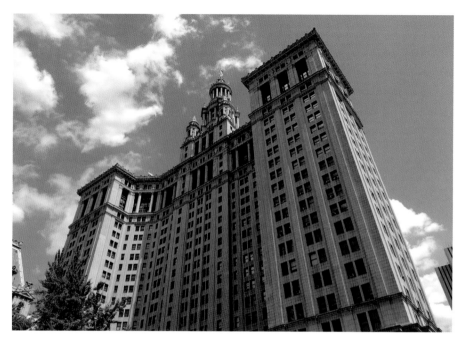

The landmark David N. Dinkins New York City Municipal Building, built in 1916, stands at the intersection of Chambers and Centre Streets. It has been the home of public radio station WNYC since 1924, offering a variety of both talk and musical programs over the years.

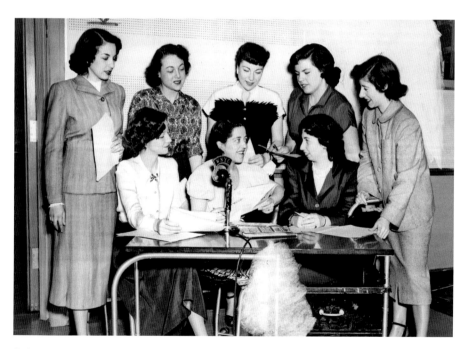

Gathered behind desk and microphone celebrating radio station WNYC's 25th anniversary in 1948 are (left to right) standing: Miriam Cutler, Dulcie Rogers, Marilyn Tack, Patti Bolton, Lynn Thiras, and seated: Anita Paige, Lillian Blake, and Rita Ostrow. Blake was producer for People's Music, East and West, a concert series from Town Hall that presented little-known folk music. She coordinated the radio station's 7th annual American Music Festival of 181 programs, including 137 live broadcasts over eleven days in February 1946.

Right: The Cotton Club, in operation between 1923–40, was a famous Harlem nightclub that featured many of the day's top black performers, including Cab Calloway and Lena Horne. A new version of the club opened in 1978. The image shows the cover of a Cotton Club program from 1938.

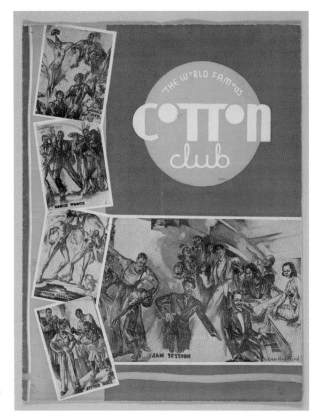

Below: Alhambra Hall on Adam Clayton Powell Jr. Boulevard in Harlem was a multipurpose venue that opened in 1926. In its early days, it hosted such singers and musicians as Bessie Smith, Jelly Roll Morton, and Billie Holiday. After closing during the Depression, the space had various uses over the years. It recently reopened as the Alhambra Ballroom, a venue for catered events.

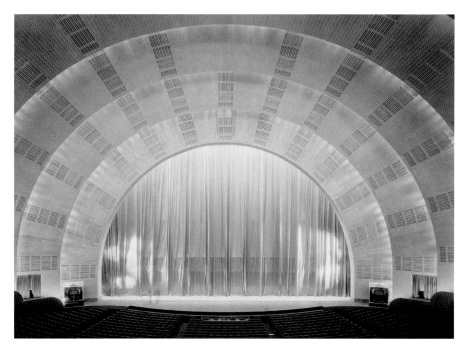

Located at Sixth Avenue and 50th Street, Radio City Music Hall is an Art Deco landmark that is part of the Rockefeller Center complex. As one of New York's best-known venues, it hosts a wide variety of concerts and other events. Musicians appearing there have ranged from Ray Charles to The Grateful Dead. At top, a view of the interior of Radio City Music Hall in 1932 shortly after it opened.

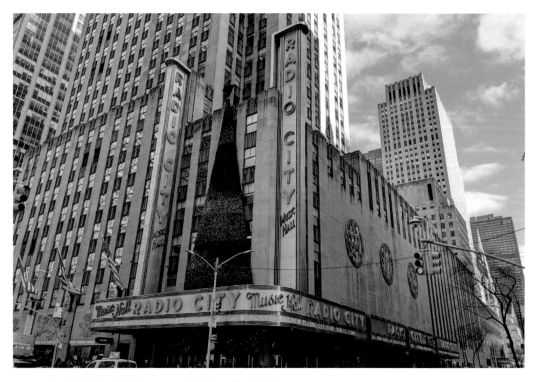

Radio City Music Hall as seen at Christmastime 2022.

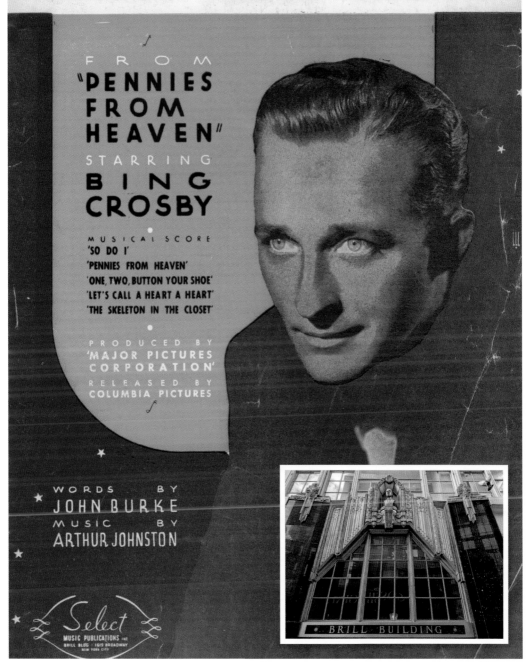

The songwriting and music publishing industry was huge in New York City, going back to the late nineteenth century and reaching a peak in the early to mid-twentieth century. The Brill Building (1619 Broadway, opened in 1931) was for a long time the nerve center of music publishing in New York. On this page, sheet music for the song "Pennies from Heaven" from the musical by the same name starring Bing Crosby (1936), a Brill Building publication.

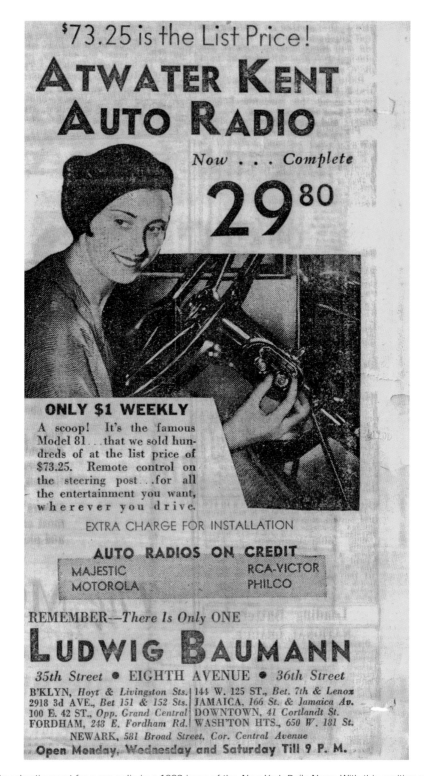

An advertisement for a car radio in a 1933 issue of the *New York Daily News*. With this exciting new automobile accessory, New York drivers could start listening to their favorite music in their cars, an obsession that continues to this day. Note that you could control it from the steering wheel, a very modern feature!

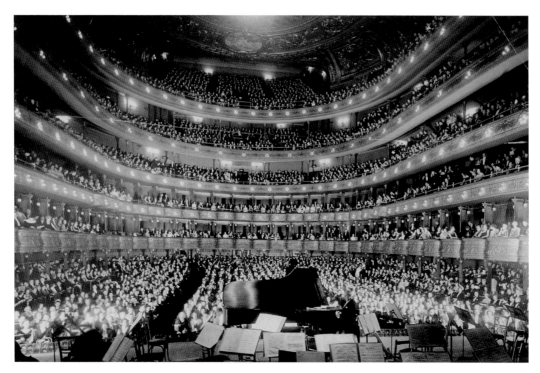

A concert at the Metropolitan Opera House by Josef Hofmann in November 1937. At the time, the Met was located at 1411 Broadway between 39th and 40th Streets. It hosted its last performances in 1966 before the Met moved to the newly built Lincoln Center complex.

Neighborhood music school student playing the violin, 238 East 105th Street, c1942.

Dancing and music on Mott Street, at a flag raising ceremony in honor of neighborhood boys in the United States Army during World War II, 1942.

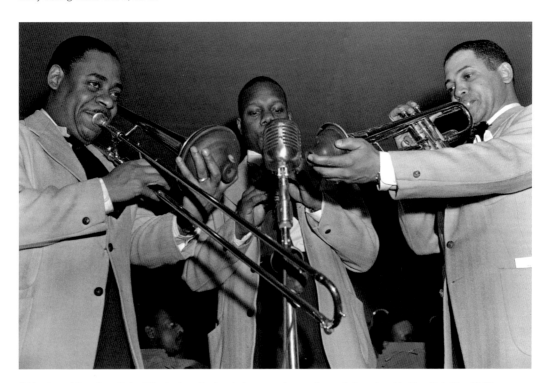

A trio of musicians from Duke Ellington's orchestra during an early morning radio broadcast in New York City, 1943.

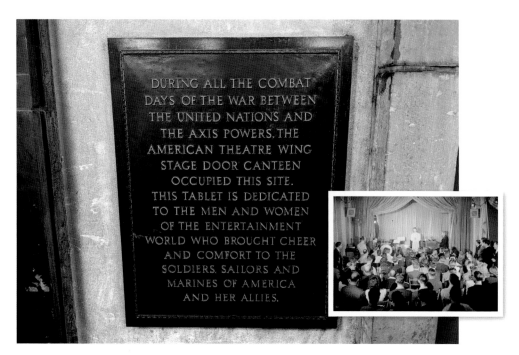

The Stage Door Canteen was an entertainment venue located on West 44th Street that was dedicated to providing musical entertainment for American and Allied troops during World War II. It inspired a movie of the same name, starring Katherine Hepburn and Tallulah Bankhead (1943). The historic spot, long gone, is commemorated with a plaque. Inset: An audience watches a performance at the Merchant Marine Theater canteen in 1944.

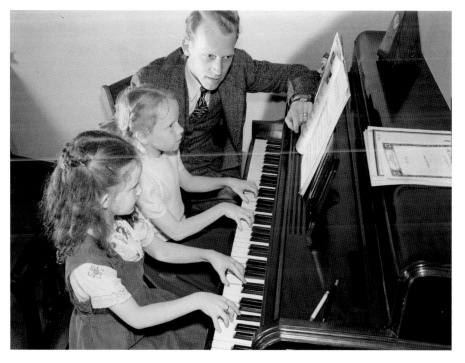

A music lesson in progress at the Church of the Good Shepherd in Brooklyn, 1944.

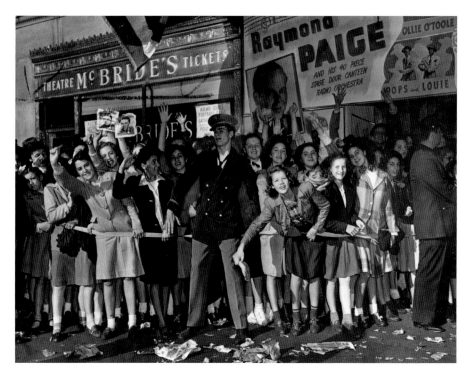

Excited female fans await the arrival of Frank Sinatra at the Paramount Theater in Times Square, in October 1944. His career had skyrocketed two years earlier after an appearance at the same venue. The Paramount Theater also hosted the Beatles in 1964 for a special concert to benefit those with cerebral palsy. The theater closed just a few years later and the former theater space was converted to office space. The theater's marquee and arch were removed in 1969 but were recreated c2002 to their current appearance.

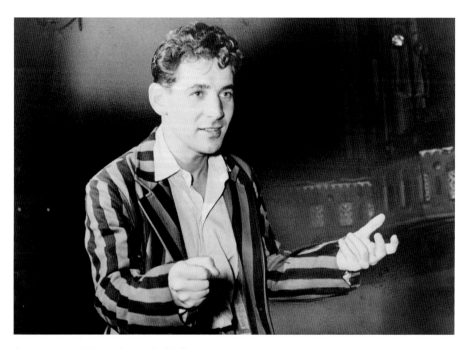

A young Leonard Bernstein seen in 1945 as conductor and musical director of the New York Symphony.

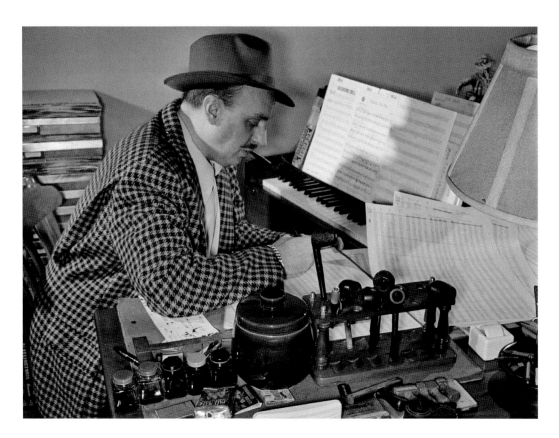

Above: Brick Fleagle works on sheet music at his home in New York City in 1946. Fleagle was a noted jazz guitarist, composer, and music transcriber. At one point he had his own sixteen-piece band. He performed with Miles Davis, among others.

Right: Hand-prepared sheet music for the song "They Won't Know Me" from the Broadway musical *Wish You Were Here*, which ran from 1952-53. The music was arranged by Luther Henderson and transcribed by Brick Fleagle for actor and singer Larry Blyden, who starred in the production. The music was used by Blyden in television appearances.

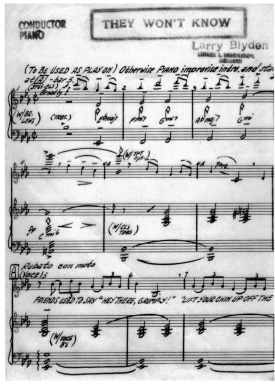

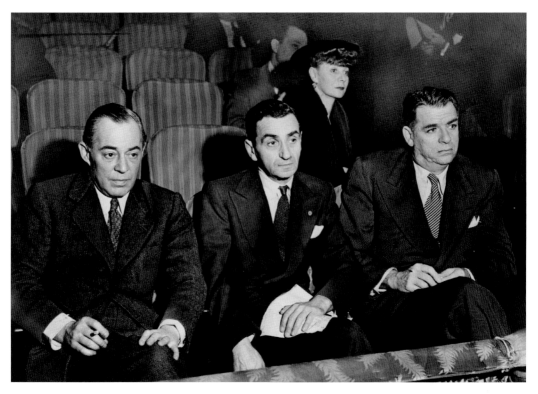

Richard Rodgers, Irving Berlin, and Oscar Hammerstein II watching Broadway hopefuls who are being auditioned on stage of the St. James Theatre in 1948.

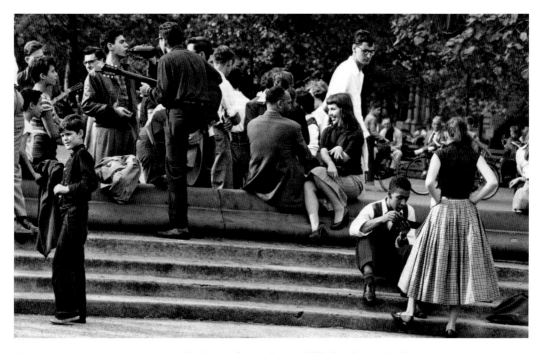

Musicians play on the fountain steps at Washington Square Park in 1953. The Greenwich Village park has been a gathering spot for creative types for many decades.

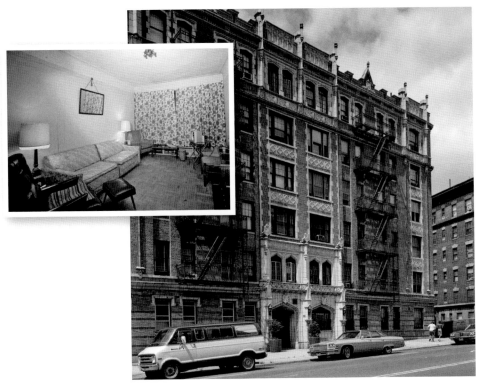

This building at 935 Saint Nicholas Avenue (at 157th Street) in Manhattan was home to the jazz musician Duke Ellington between 1939 and 1961. It was declared a National Historic Landmark in 1976. Inset: Duke Ellington's living room in apartment 4A.

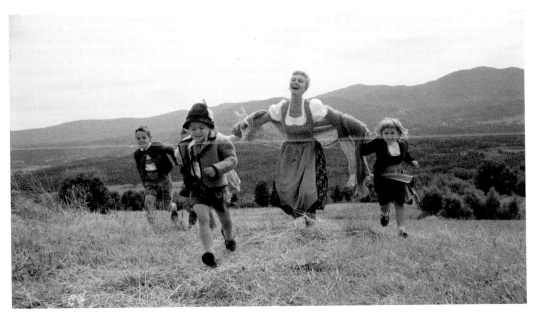

Actress Mary Martin with children, during a production of the Broadway musical *The Sound of Music* at the Lunt-Fontanne Theater in 1959. The musical won a Tony Award for Best Musical. The film version of the show (1965) starred Julie Andrews.

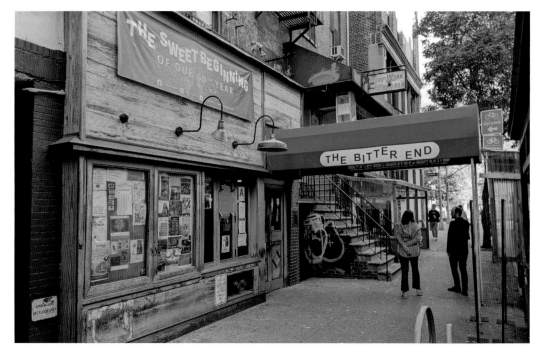

The Bitter End, at 147 Bleecker Street, is the city's oldest rock club. Dating to 1961, the small club has seen the likes of Bob Dylan (who frequented the club), Stevie Wonder, Neil Diamond, and Jackson Browne perform on its stage.

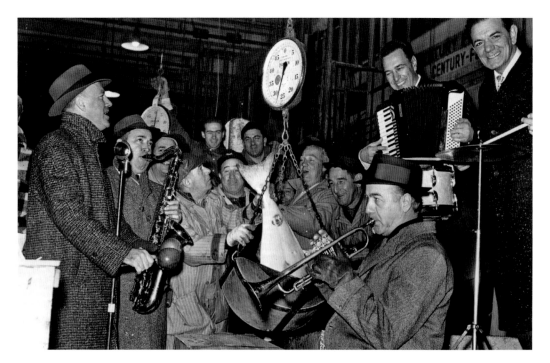

Joe Murphy's Filet Harmonicats entertain at Fulton Fish Market (now the location of South Street Seaport) as Danny Brooks weighs a fish, 1962. Left to right: Joe Murphy (leader), Charles Sage (sax), Sal Trombetta (accordion), Joe De Carlo (drums), and Dick Allen (trumpet).

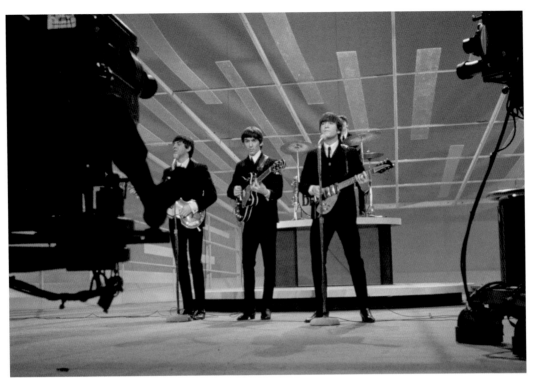

The Beatles appear on the *Ed Sullivan Show* in February 1964. Their arrival in New York City that month was met by thousands of screaming fans—Beatlemania had gripped the nation. More than 70 million viewers watched their appearance on the popular variety show, where they sang "All My Loving," "Till There Was You," "I Saw Her Standing There," and "I Want to Hold Your Hand."

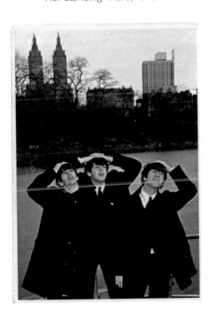
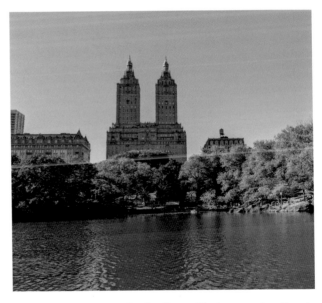

On their first trip to the United States in February 1964, three of the Beatles (George Harrison was absent) made a surprise visit to Central Park, walking around and taking in the sights. In this 1964 trading card image (along with a 2022 view of the same spot), they are seen clowning around at the lake. The twin-towered building in the background is the San Remo, a 1930 Art Deco landmark on Central Park West between 74th and 75th Streets.

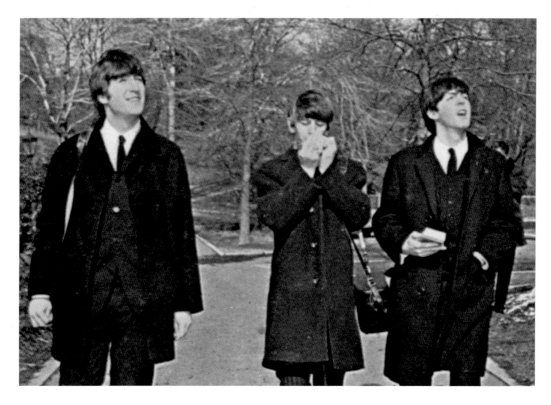

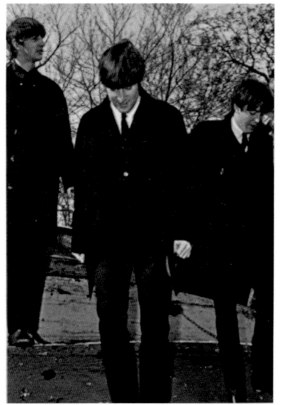

Above: Another image of three of the Beatles exploring Central Park in February 1964.

Left: John, Paul, and Ringo standing on rowboats at Central Park, February 1964. Below, a Central Park rowboat in 2022.

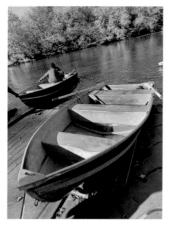

Opposite above: The Beatles at a press conference at the Hotel Warwick (Sixth Avenue and 54th Street) on their arrival in New York City during their second U.S. tour, August 13, 1965.

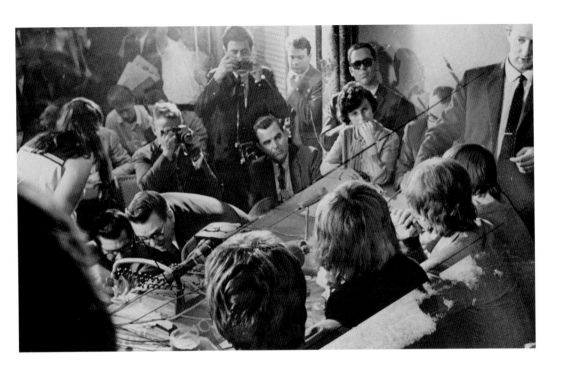

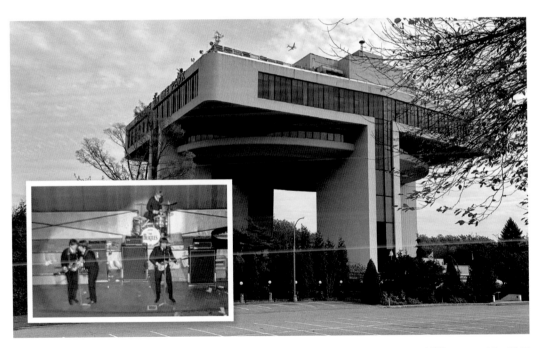

The eighteen-story-high Terrace on the Park in Flushing Meadows Park was opened in 1963 as part of the 1964 World's Fair complex, complete with a heliport on the roof. The Beatles' helicopter landed there on August 15, 1965, to get them just minutes away from Shea Stadium for their historic concert. That's not the only musical association the building has; before she made it big as a musician, Madonna worked at Terrace on the Park. As of 2022, the venue hosts weddings and special events. Inset: The Beatles on stage for a charity concert at the Paramount Theatre (Broadway and 43rd Street) on September 20, 1964, the last stop of their U.S. tour. They are probably performing "Twist and Shout" in this image.

Bleecker Street, in Greenwich Village, is the title and subject of a 1964 song by Simon and Garfunkel, a New York duo who often celebrated their hometown in song. The lyrics proclaim thirty dollars pays your rent on Bleecker Street. These days, a studio apartment on Bleecker goes for several thousand dollars a month. Seen here, the intersection of Bleecker and Lafayette Streets.

The 59th Street Bridge (aka the Queensboro Bridge and the Edward Koch Bridge) is one of the city's ubiquitous landmarks. Completed in 1909, it was the first bridge to connect Manhattan and Queens. It gained additional fame in 1966 when Simon and Garfunkel released the "59th Street Bridge Song (Feelin' Groovy)." An upbeat song about living joyfully, the song celebrates "looking for fun and feeling groovy."

Right: Musician and singer Louis Armstrong plays trumpet while Joey Adams, president of the American Guild of Variety Artists Youth Fund, presents him with an award at Carnegie Hall, 1966.

Below: The grave of Louis Armstrong in the Flushing Cemetery in Queens gets many visitors, some of whom add adornments and trinkets to the top of the stone. During the last years of his life, Armstrong lived in a house in East Elmhurst; it has since been converted into a museum celebrating his life and legacy.

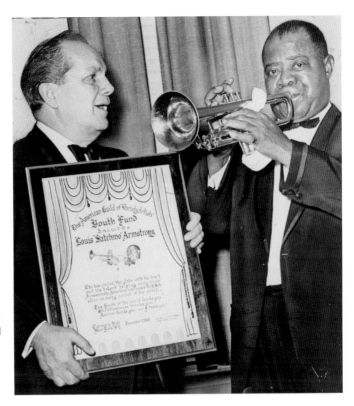

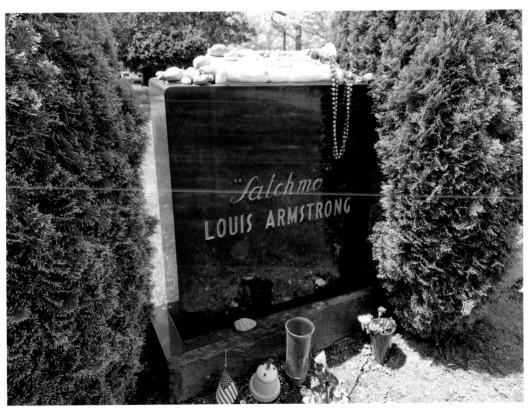

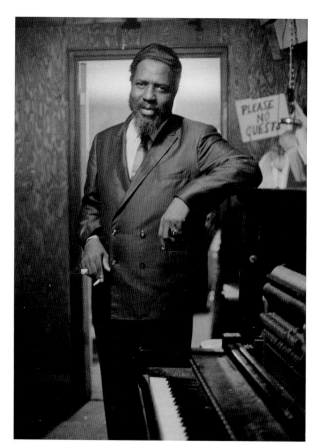

Left: Jazz pianist and composer Thelonious Monk (1917-1982) at the Village Gate in 1968. The Village Gate was located at the corner and Thompson and Bleecker Streets. First opened in 1958, it closed in 1994. Bob Dylan wrote "A Hard Rain's A-Gonna Fall" in the building in 1962.

Below: Folk singer Joan Baez performing at an anti-war rally at the Central Park Bandshell in 1968. During the Vietnam War era in New York City, music was a powerful form of protest against American military involvement overseas.

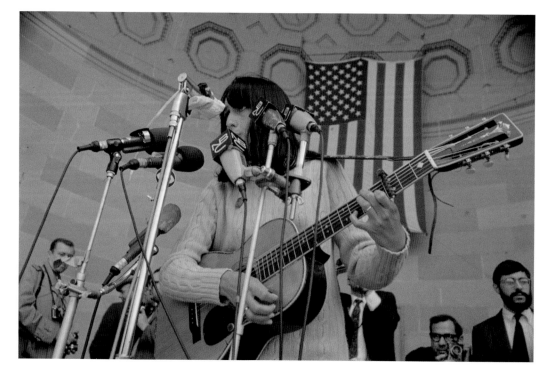

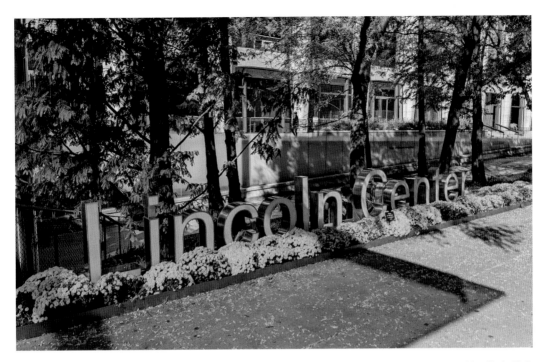

An unassuming sign announces that you are entering the 16-acre campus of Lincoln Center, New York City's premier performing arts complex, which stretches from 60th to 66th Streets between Broadway and Amsterdam Avenue. It is home to eleven resident arts organizations.

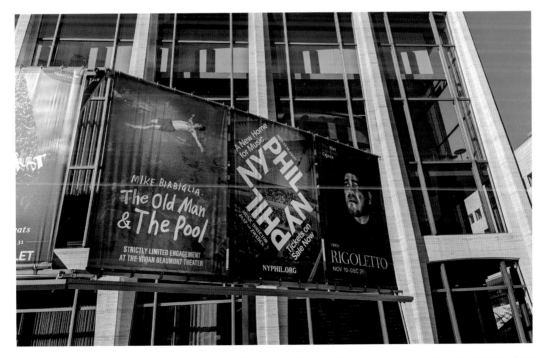

Posters in front of Lincoln Center advertise the current offerings at the various venues within the complex. Built between 1959-1969 (President Eisenhower attended the groundbreaking ceremony), the complex opened in 1962 with the debut of the Philharmonic Hall.

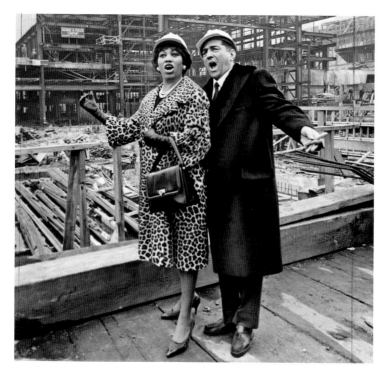

Opera stars Leontyne Price and Robert Merrill deliver an aria at topping-out ceremonies for the new Metropolitan Opera House at Lincoln Center in 1964. The $42.7 million, fourteen-story building, in the background, is the largest of five structures in the center.

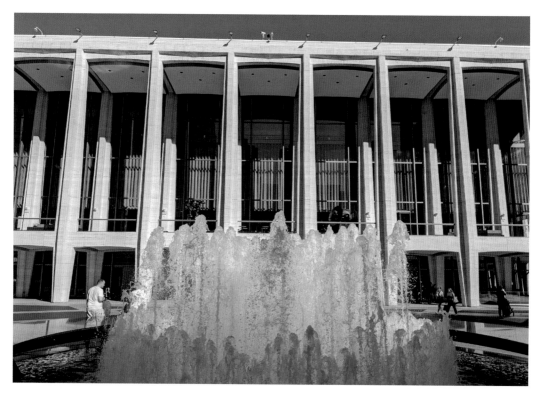

The iconic Revson Fountain is the centerpiece of the Lincoln Center complex of buildings. It was completed in 1964 and redesigned in 2009. In its current iteration, the fountain includes 353 jets that can shoot water as high as 60 feet in the air.

David Geffen Hall is a concert hall that is home to the New York Philharmonic. With over 2,000 seats, it used to be known as Avery Fisher Hall, and prior to that as Philharmonic Hall. The author's high school graduation took place there.

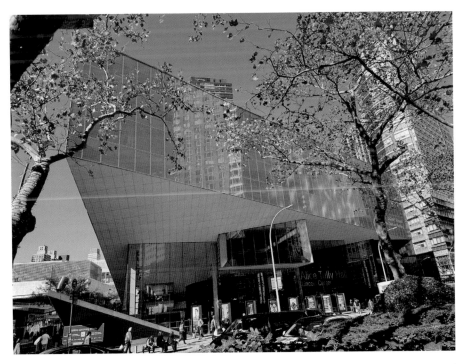

Alice Tully Hall is a 1,086-seat venue at Lincoln Center that is host to the Chamber Music Society of Lincoln Center, among other artists. It was completed in 1969.

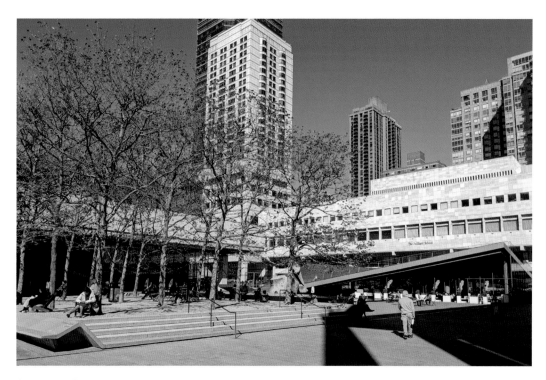

The Juilliard School, established in 1905, opened at its current location in Lincoln Center in 1969. This private school educates students in the various branches of the performing arts—music, dance, and drama—and has a worldwide reputation for excellence.

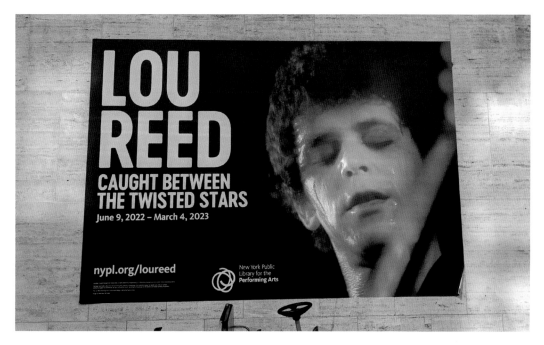

A sign advertising a Lou Reed (1942-2013) exhibition on the wall of one of the Lincoln Center complex buildings. Famed for his work as a member of the rock band The Velvet Underground, Reed was a quintessential New York musician. In 1965-66, Reed lived with fellow musician John Cale in an unheated apartment at 450 Grand Street.

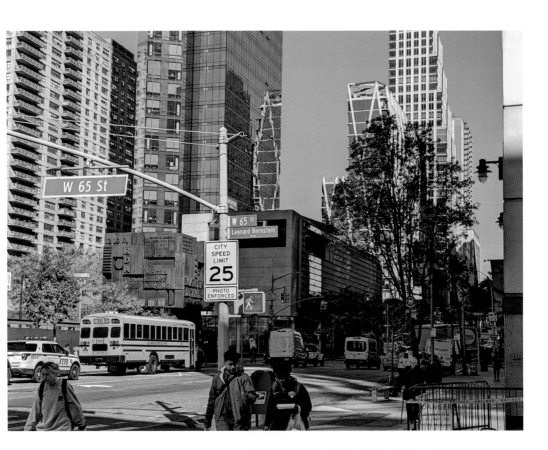

Above: Located within the Lincoln Center complex of buildings, 65th Street between Broadway and Amsterdam Avenue was renamed after the conductor and West Side Story composer Leonard Bernstein (who had died in 1990) in 1993. Bernstein was for many years the music director of the New York Philharmonic.

Right: Cuban-born singer La Lupe (1936-1992) performing in New York City in 1970. Lupe, who died in the Bronx, was known as the "Queen of Latin Soul."

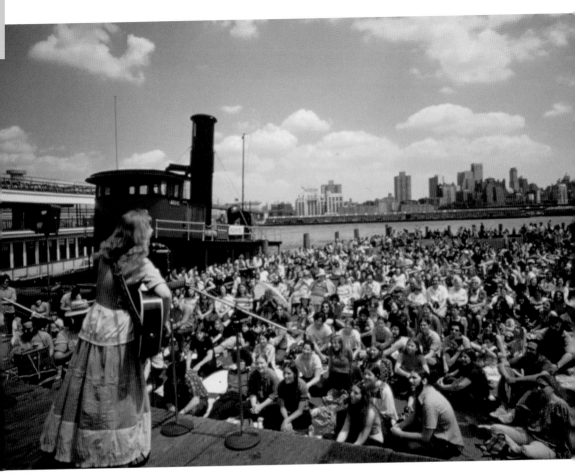

A folk music concert at South Street Seaport, June 1973. This photo predates the revitalization and restoration of the South Street Seaport district to the tourist attraction it is today.

Opposite above: A lunchtime classical music concert at Bryant Park, 1973. The park, which dated back to 1884, was on its way downhill though and by the early 1980s was seen as an unsafe place frequented by drug dealers until it was cleaned up and refreshed thanks to Project for Public Spaces working in conjunction with the Bryant Park Restoration Corporation. Removal of shrubbery and installation of lighting helped rejuvenate the park, as well as the introduction of hundreds of movable chairs, food concessions, and concert events.

Opposite below: Large audience at a concert by singer Judy Collins at the Schaefer Bandstand in Central Park. The towers of Midtown Manhattan form a dramatic backdrop, June 1973.

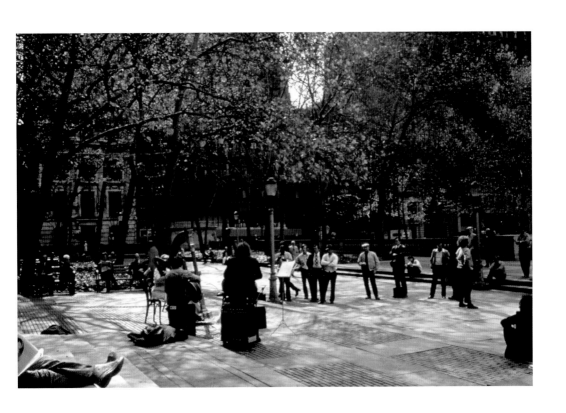

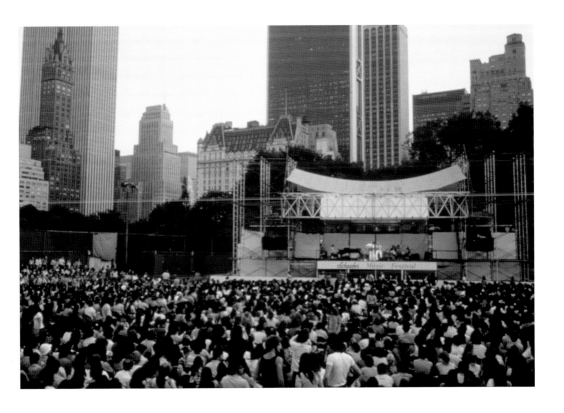

The twin apartment buildings at 96-98 St. Marks Place grace the cover of rock band Led Zeppelin's 1975 album *Physical Graffiti*. The album art features red all capital letters making up the words "Physical Graffiti" placed on the building's windows. The five-story buildings were cropped to four stories to allow for placement on the square album cover. The buildings also appear in the 1981 "Waiting On A Friend" Rolling Stones music video.

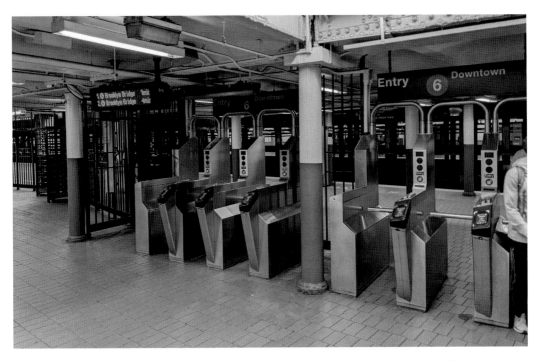

The turnstiles at the Astor Place 8th Street subway station were the site where the cover photograph was taken for Billy Joel's 1976 *Turnstiles* album. Seen here, the Astor Place turnstiles in 2022.

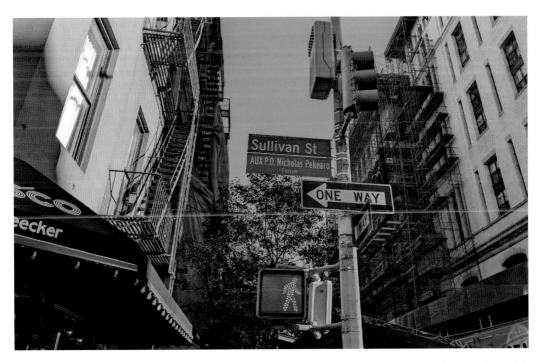

Many New York City streets have gained fame from being mentioned in songs. Sullivan Street in Greenwich Village is another example—made famous by the line from Billy Joel's "Movin' Out" (1977): "He works for Mr. Cacciatore down on Sullivan Street, across from the medical center…" Another Billy Joel song, "Big Man on Mulberry Street," features a NYC street name in its title.

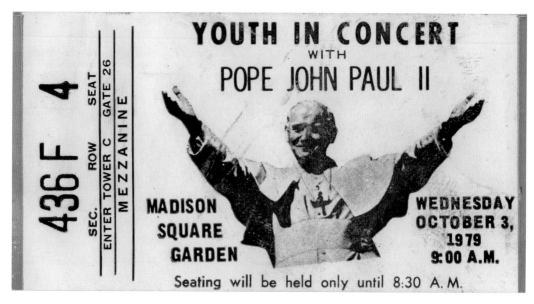

A ticket to the Youth in Concert event with Pope John Paul II at Madison Square Garden on October 3, 1979. It was the first visit of a Pope to the United States and caused a great excitement in the city, with people clamoring to see him as he made his way from one event to another.

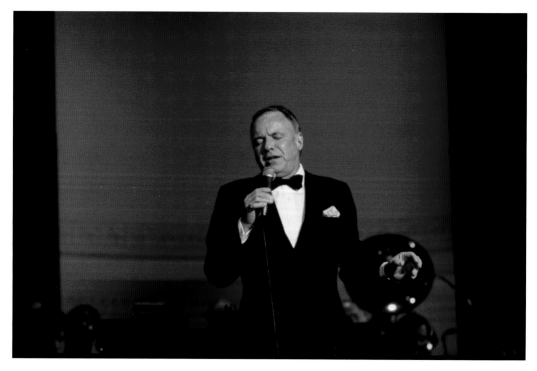

Frank Sinatra sings at Carnegie Hall in 1980. He appeared at Carnegie Hall dozens of times from 1945 through the 1980s. His 1977 song "New York, New York" has become one of the most frequently played at various large-scale events in the city, including just after midnight on New Year's Day in Times Square.

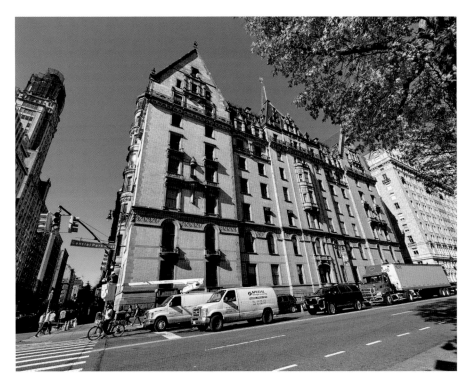

The beautiful co-op apartment building known as the Dakota, located at 72nd Street and Central Park West, is a landmark residential structure that was completed in 1884, at a time when much of the land surrounding the park was still undeveloped. Designed by Henry Janeway Hardenbergh, the building would later become famous as the home of John Lennon and his wife Yoko Ono. Lennon was murdered in front of the Dakota in 1980. His widow continued to live in the building after his death.

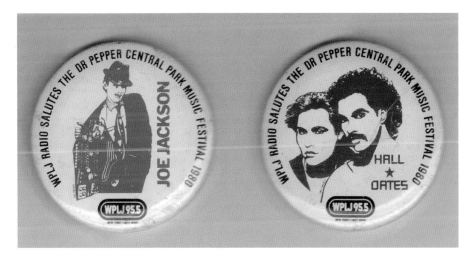

A music festival was held at the Wollman Rink in Central Park between 1966 and 1980. First called the Rheingold Music Festival, the name was changed to Schaefer Music Festival in 1967. In 1977, it was changed again to the Dr. Pepper Central Park Music Festival, which ran until 1980; in 1981, it moved to the Hudson River's Pier 84. Performers for the Dr. Pepper festivals included the Little River Band, Firefall, Harry Chapin, Jimmy Buffet, Pete Seeger, Bonnie Raitt, and Frankie Valli. These two pinback buttons are from the 1980 festival.

The Ultimate Simon And Garfunkel Concert: Live In Central Park!

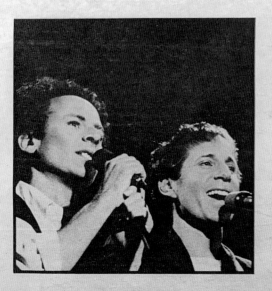

▶Hear the music that fired over 500,000 fans on a chilly New York evening. The great 1981 Simon and Garfunkel reunion performance is now available as a 20-song two-record set with a 12-page souvenir booklet, all at a very special price.

Featuring:

Mrs. Robinson	April Come She Will	Slip Slidin' Away	Fifty Ways To Leave Your Lover
Homeward Bound	Wake Up Little Susie	A Heart In New York	The Boxer
America	Still Crazy After All These Years	Kodachrome/Mabellene	Old Friends
Me And Julio Down By The Schoolyard	American Tune	Bridge Over Troubled Water	The 59th Street Bridge Song (Feelin' Groovy)
Scarborough Fair	Late In The Evening		The Sounds Of Silence

SIMON AND GARFUNKEL
THE CONCERT IN CENTRAL PARK

Produced by Paul Simon, Art Garfunkel, Phil Ramone and Roy Halee
On Warner Bros. Records & Tapes

A 1982 advertisement for the two-record live recording of Simon and Garfunkel's epic 1981 Central Park concert. More than 500,000 people crowded the Great Lawn to hear the reunited duo perform many of their classic hits along with some of Paul Simon's solo material.

The sepia-toned album cover of Billy Joel's 1983 multi-platinum release *An Innocent Man* was shot on the steps of 142 Mercer Street, which as of 2022 housed the Lure Fishbar. Here the author recreates Joel's iconic pose (and album cover, tongue-in-cheek version) on the steps.

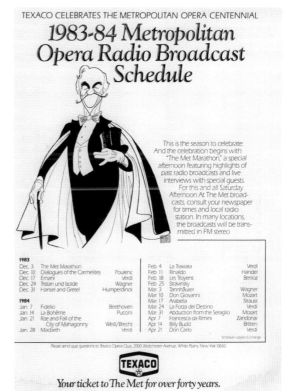

An advertisement for the 1983-84 (100th anniversary season) Metropolitan Opera broadcast schedule sponsored by Texaco. The drawing is by Al Hirschfeld, an artist who for decades sketched hundreds of celebrities, notably Broadway stars and musicians.

Strawberry Fields, a five-acre landscaped area near the 72nd Street entrance to Central Park, celebrates the life of former Beatle John Lennon, who lived across the street in the Dakota apartment building and enjoyed walking in the park. The memorial opened on October 9, 1985, what would have been Lennon's 45th birthday.

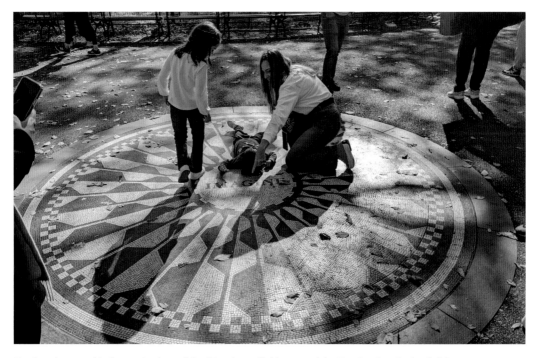

The Imagine mural is the centerpiece of the Strawberry Fields memorial, attracting hundreds of visitors every day, and even more on the anniversaries of Lennon's birth and death. People come to pay tribute to Lennon and pose for pictures with the mural. Nearby a musician can often be found playing Lennon compositions.

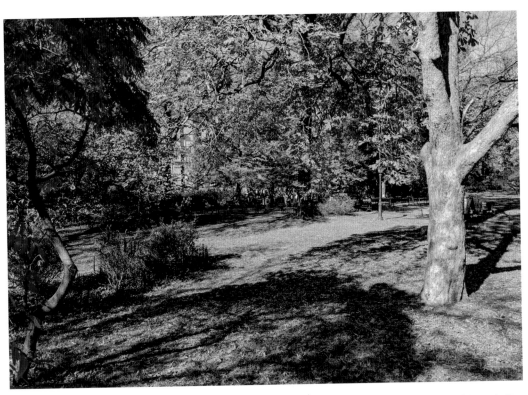

Looking north within Strawberry Fields, toward the Imagine Mural. Below: John Lennon art prints and other souvenirs are offered for sale at Strawberry Fields in Central Park.

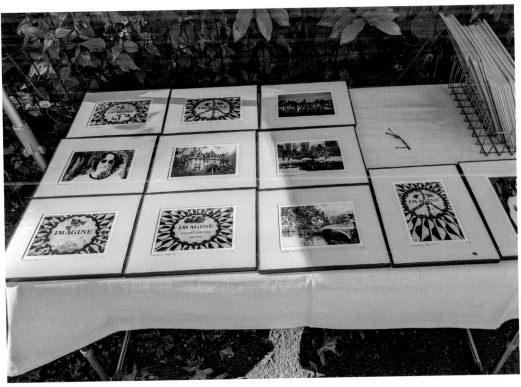

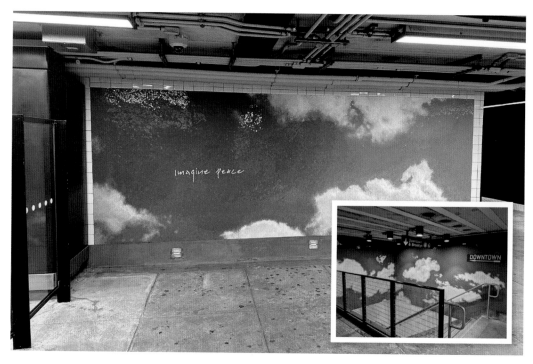

When the 72nd Street IND line subway station was renovated in 2018, several mosaics designed by Yoko Ono were added to the station walls. Featuring sky and clouds, they were inspired by the John Lennon song, "Imagine."

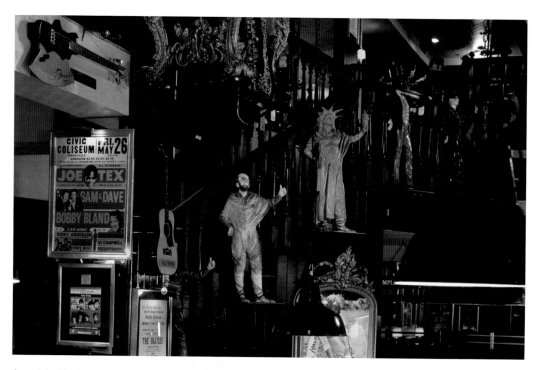

A peek inside the Hard Rock Café New York in 1986, when it was located at 221 West 57th Street. The Hard Rock is an international music-themed chain restaurant known for its walls, ceilings, and windows lined with one-of-a-kind music memorabilia, and also for occasional live concerts held at some of its venues.

How many of these shows have you seen?

THE LONGEST RUNNING SHOW
IN B'WAY HISTORY
BEST MUSICAL
1976 TONY & PULITZER PRIZE WINNER

A CHORUS LINE

Mon.-Sat. 8 PM, Wed. & Sat. 2 PM; All performances $45, 40, 30. Tele-charge: (212) 239-6200. (24 hrs. a day • 7 Days a Week) Mail Orders: P.O. Box 998, N.Y., N.Y. 10108. GROUPS: (212) 398-8383/598-7107. Also at Ticketron.

SHUBERT THEATRE, 225 W. 44th St., 239-6200.

"B'WAY'S NO. 1 HIT!"—*Liz Smith, Daily News*
THE BEST PLAY OF THE SEASON!
1983 N.Y. DRAMA CRITICS CIRCLE AWARD
NEIL SIMON'S *new comedy*

BRIGHTON BEACH MEMOIRS

Directed by GENE SAKS
Call Chargit: 944-9300 Groups: (212) 757-8646
★ NEIL SIMON THEATRE, 250 W. 52nd St. N.Y.C. 10019.
(212) 757-8646

BEST MUSICAL 1983
7 TONY AWARDS
1983 OUTER CRITICS CIRCLE AWARD
OUTSTANDING MUSICAL
GRAMMY WINNER
BEST CAST SHOW ALBUM
THE ANDREW LLOYD WEBBER/T.S. ELIOT
INTERNATIONAL AWARD-WINNING
MUSICAL

CATS

NOW AND FOREVER.
Mon.-Sat. at 8, Mats. Wed. & Sat. at 2.
CALL TELE-CHARGE TODAY
(212) 239-6200
24 Hours a Day • 7 Days a Week
GROUP SALES: (212) 239-6262 • Also at Ticketron.
★ WINTER GARDEN THEATRE, 50th St. & B'way.

WINNER!
6 TONY AWARDS, 1982

DREAMGIRLS

THE MUSICAL OF THE EIGHTIES
Tues.-Sat. 8 PM. Mats. Wed. & Sat. 2 PM, Sun. 3 PM.
CALL TELE-CHARGE: (212) 239-6200
24 Hours a Day • 7 Days a Week
GROUPS: 239-6262 • Also at Ticketron.
IMPERIAL THEATRE, 249 West 45th St. NY, NY 10036.

"BLAZING THEATRICAL FIREWORKS!"
—*Frank Rich, N.Y. Times*
"BRILLIANT! IT SOARS!"
—*Joel Siegel, WABC-TV*
"THE STUFF THAT BROADWAY
IS MADE OF!"—*U.P.I.*

42ND STREET

Tues.-Sat. at 8, Mats. Wed. & Sat. at 2, Sun. at 3.
Call TELE-CHARGE (212) 239-6200
24 Hours a Day • 7 Days a Week
GROUPS: (212) 398-8383 • Also at Ticketron.
MAJESTIC THEATRE, 247 W. 44th ST.

WINNER!
BEST AMERICAN PLAY
1984 PULITZER PRIZE
1984 N.Y. DRAMA CRITICS CIRCLE AWARD

GLENGARRY GLEN ROSS

A new play by DAVID MAMET
CALL TELECHARGE: (212) 239-6200
24 Hours a Day • 7 Days a Week
Groups: (212) 239-6262 • Also at Ticketron
Mon.-Sat. 8 (exc. Thurs.); Mats. Wed. & Sat. 2, Sun. 3
★ GOLDEN THEATRE, 45th St. W. of B'way. 239-6200.

BROADWAY'S NEWEST MUSICAL HIT!

HARRIGAN 'n HART

A NEW MUSICAL
starring
MARK HAMILL
HARRY GROENER
CHRISTINE EBERSOLE
ARMELIA McQUEEN
CALL TELE-CHARGE: (212) 239-6200
24 Hours a Day • 7 Days a Week
Groups: 239-6262 • Also at Ticketron
Tues.-Sat. 8; Mats. Wed. & Sat. 2, Sun. 3
LONGACRE THEATRE, 220 W. 48th St.

"'HURLYBURLY' MAKES THEATRE
HISTORY!"—*Jack Kroll, Newsweek*

HURLYBURLY

(starring in alphabetical order)
SUSAN ANTON CHRISTINE BARANSKI
ALLISON BARTLETT
JOHN CHRISTOPHER JONES
HARRIS LASKAWY RON SILVER
JERRY STILLER
in a new play by DAVID RABE
directed by MIKE NICHOLS
CALL TELECHARGE: (212) 239-6200
24 Hours a Day • 7 Days a Week
Group Sales: (212) 239-6262
★ BARRYMORE THEATRE, 243 W. 47th St. 239-6200.

★ *Indicates shows equipped with Infrared Listening System.*

The first page of an alphabetical directory of Broadway shows running in 1985 features some of the biggest musicals of the 1980s, including *A Chorus Line*, *42nd Street*, and *Cats*, as well as *Dreamgirls*, self-billed as "The Musical of the Eighties."

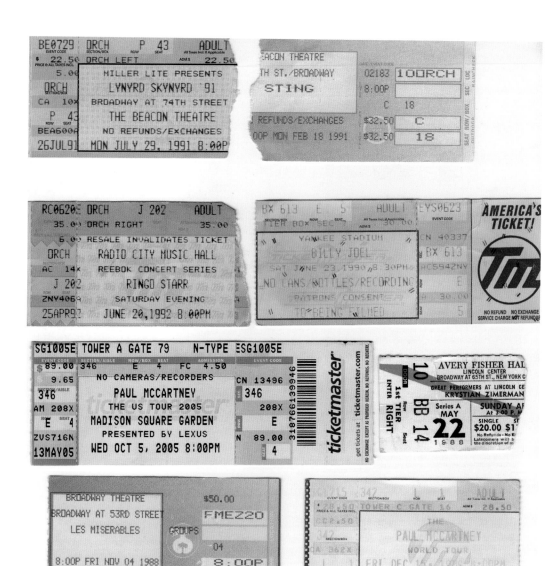

Ticket stubs from some 1980s and 1990s New York City concerts, including Paul McCartney at Madison Square Garden 1989, Billy Joel at Yankee Stadium 1990, Lynyrd Skynyrd at the Beacon Theater in 1991, Sting at the Beacon Theater in 1991, and Ringo Starr at Radio City Music Hall in 1992.

Opposite above: First Lady Nancy Reagan attended the smash Broadway musical *Phantom of the Opera* in March 1988. She is seen here posing with its stars, Sarah Brightman and Michael Crawford.

Opposite below: The music club CBGB was founded on the Bowery in 1973 and quickly became a proving ground for many punk and new wave music acts, such as the Ramones, Blondie, the Talking Heads, and Misfits. The venue closed in 2006 after a final performance by Patti Smith. As of 2023, the building, located at 315 Bowery, is home to the clothing store John Varvatos.

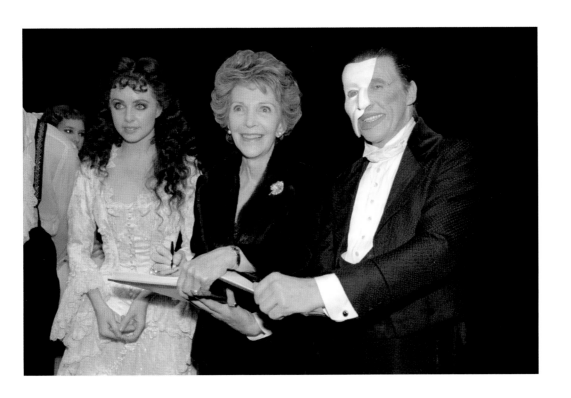

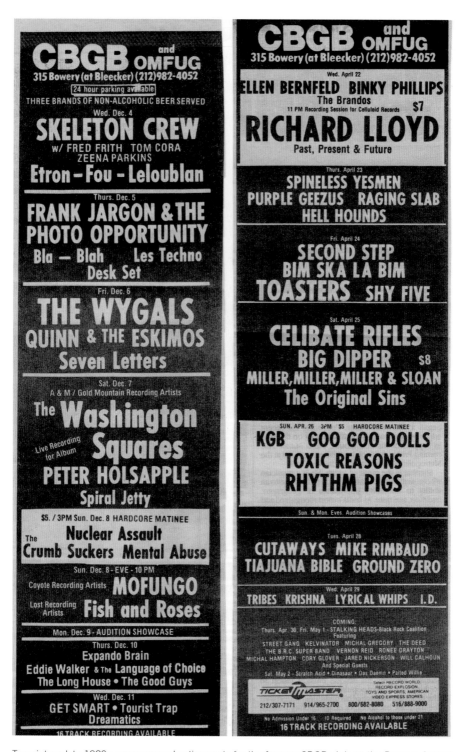

Two vintage late 1980s newspaper advertisements for the famous CBGB club on the Bowery. Among the acts that appeared in just these two ads were Peter Holsapple (who co-founded the dB's and would play with REM's touring band) and the Goo Goo Dolls before they achieved fame.

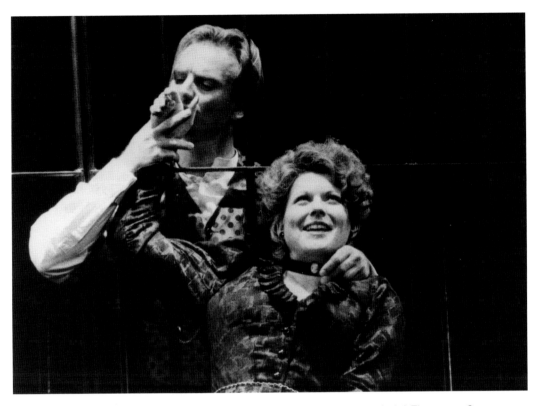

In 1989, Sting starred as Macheath in the revival of Berthold Brecht's musical *A Threepenny Opera* at the Lunt-Fontanne Theater. The show was not a success, running only from November 5 through December 31. The photo above shows Sting and co-star Kim Criswell as provided in the press kit for the show, along with a piece of the press release that came in the press kit.

CONTACT: SHIRLEY HERZ
 PETE SANDERS (Newspapers and TV)
 GLENNA FREEDMAN (Radio and
 Magazines)

"3 PENNY OPERA" STARRING STING,

PLAYING AT BROADWAY'S LUNT-FONTANNE THEATRE

3 PENNY OPERA, starring Sting, is playing at Broadway's Lunt-Fontanne Theatre (205 West 46th Street) . 3 PENNY OPERA is presented by Jerome Hellman in association with Haruki Kadowkawa and James M. Nederlander.

3 PENNY OPERA has book and lyrics by Bertolt Brecht and music by Kurt Weill. The translation for this new production is by Michael Feingold. John Dexter directs. Musical staging is by Peter Gennaro. Musical direction is by Julius Rudel. Scenery and costumes are by Jocelyn Herbert and lighting by Andy Phillips and Brian Nason.

Some NYC buildings are places where musicians lived or where music was written. Others, like this apartment building at 90 Bedford Street, have a musical connection for a different reason. This nineteenth-century structure was used in exterior shots of the hit television show *Friends* from 1994 to 2004, as the location of Monica and Rachel's apartment. It's nearly impossible to see this building and not hear the ubiquitous theme song of the show, "I'll Be There For You" by the Rembrandts.

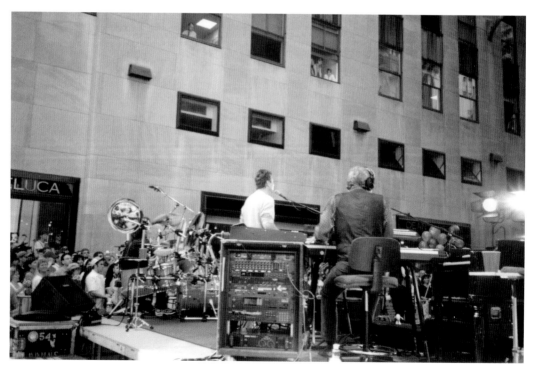

The rock band Chicago performs at Rockefeller Center in 1997 as part of the Today Show's early morning Summer Concert Series. Making stops at the New York morning shows has long been a requisite for musicians promoting new albums or concert tours.

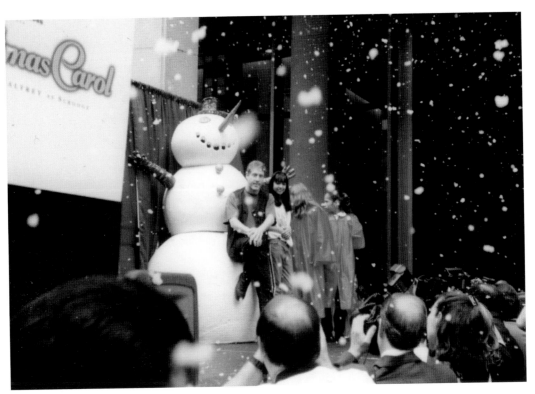

Roger Daltrey of the rock group The Who appeared as Scrooge in the 1998 production of *A Christmas Carol*, which ran from November 27 to December 27 in the Theater at Madison Square Garden. He is seen here in a promotional appearance for the show in the plaza on Seventh Avenue in front of the famous venue.

A signed CD cover of the cast recording of *Footloose*, a Broadway musical based on the 1984 hit film of the same name. The production appeared at the Richard Rodgers Theater between October 1998 and July 2000.

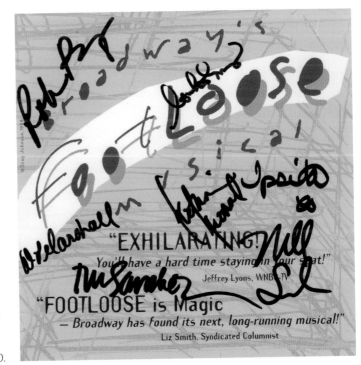

Sting performs at Rockefeller Center on a chilly Friday morning in 1999 as part of the Today Show Summer Concert Series just as his new album *Brand New Day* was being released.

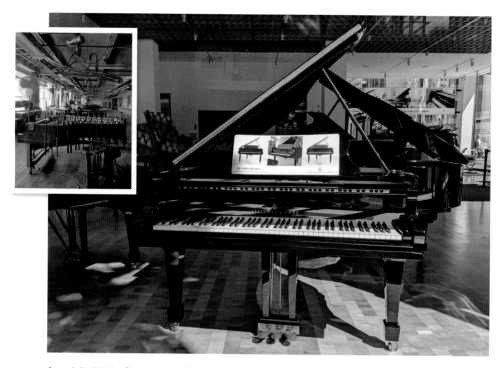

A peek inside the Steinway and Sons piano showroom on 6th Avenue between 43rd and 44th Streets. Steinway has been a New York City fixture since the 1800s. Founded in the city, the firm developed a large industrial complex in Queens where it manufactured (and still does to this day) its world-famous pianos. Inset: A piano in progress in the Queens Steinway factory.

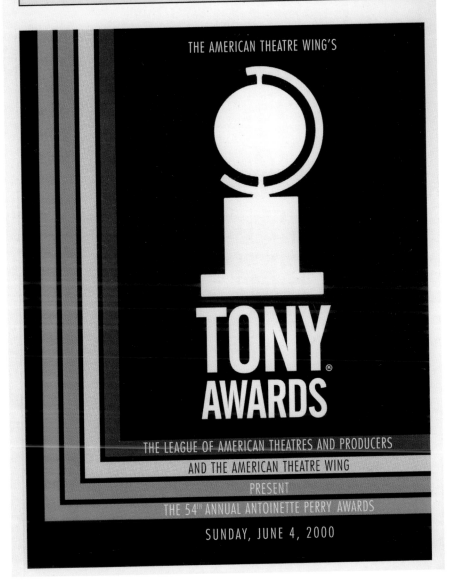

The cover for the Playbill of the 2000 Tony Awards, held at Radio City Music Hall. Every year, the Tony Awards give out honors to the best of Broadway. in the musical category, awards include best musical, leading actor and actress, featured actor and actress, director, score, and choreographer. The winner for best musical of 2000 was *Contact*, by Susan Stroman and John Weidman, which consisted of three one-act dance plays.

Paul McCartney performed an historic pair of concerts at Yankee Stadium in July 2011. In this image he is performing his song "Nineteen Hundred and Eighty-Five" there. He'd also given a farewell concert to Shea Stadium in 2008 and a series of three concerts at the newly opened Citi Field in 2009.

Thousands of spectators watch as McCartney plays at a lunchtime pop-up concert in Times Square on October 10, 2013, to celebrate the release of his new album, *New*. He would perform another surprise concert in New York City, this time at Grand Central Station, for his album *Egypt Station*, on September 8, 2018.

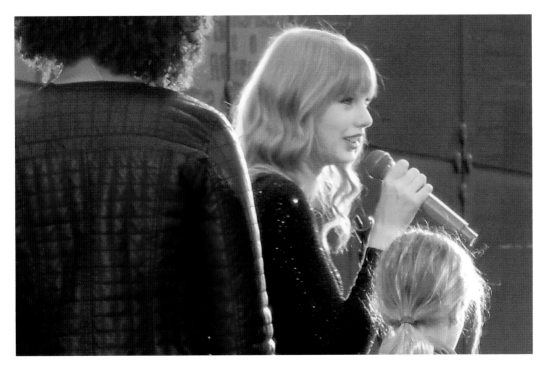

Taylor Swift performs a free outdoor mini concert on 44th Street in Times Square in October 2012, singing several songs in support of the release of her *Red* album, which marked the transition from country to pop star and the tremendous increase in her popularity. The performance was broadcast on the television show *Good Morning America*.

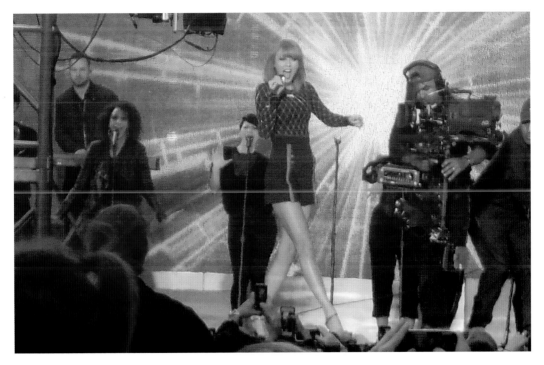

Taylor Swift performs another free outdoor mini concert in Times Square, this time on 43rd Street, in October 2014, in support of the release of her blockbuster album *1989*.

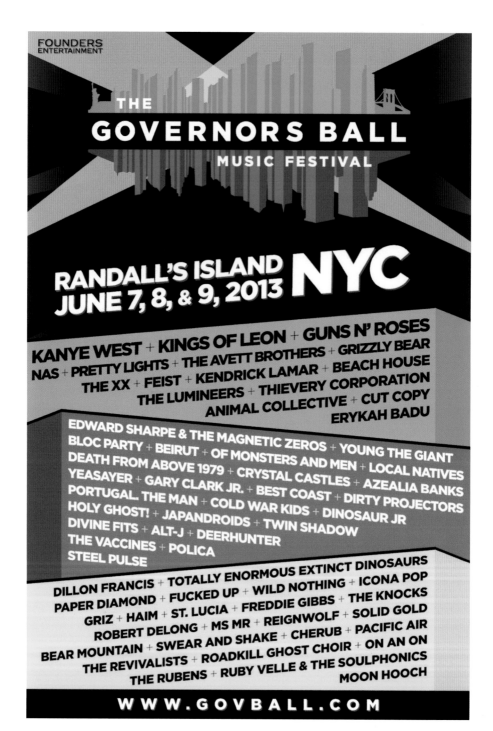

Governors Ball June 2013, Randalls Island. Headliners included Kanye West, The Lumineers, Kendrick Lamar, and Guns 'N' Roses. The festival began in 2011. Musicians appearing there over the years included Beck, Modest Mouse, Jack White, the Strokes, The Black Keys, Lorde, Drake, Franz Ferdinand, Eminem, Travis Scott, Lil Wayne, Stevie Nicks, Miley Cyrus, Billie Eilish, Post Malone, Kid Cudi, and Halsey. The festival was held at Randalls Island Park until 2020; in 2021 and 2022, it was held at Citi Field in Queens.

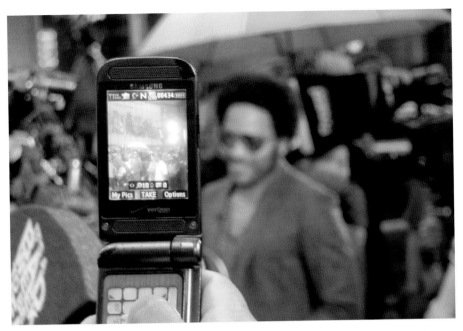

Singer Lenny Kravitz being photographed by a spectator as he makes an appearance in Times Square, August 2013. Kravitz was born in New York and spent his childhood there.

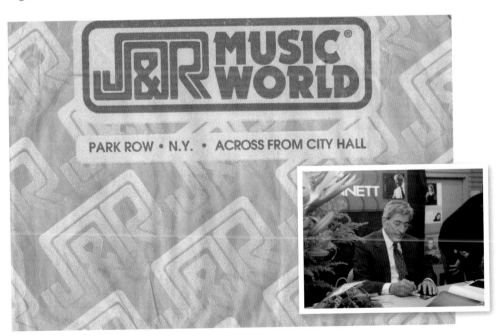

J&R Music World, a major Manhattan music and electronics retailer, was founded in 1971 on Park Row across from City Hall and for more than forty years was one of the most famous music retailers in the city. Numerous famous musicians performed or did album signings there, including Michael McDonald, Joe Walsh (of the Eagles), Bruce Hornsby, Tony Bennett, Andy Summers (of the Police), and Jeff Bridges (known as an actor but also an accomplished musician). It went out of business in 2014. Shown here is an iconic bag from the defunct store, c2010. Inset: Queens-born singer Tony Bennett signs at J&R Music World in 1999.

Music venues often change names based on their sponsors or ownership. The Palladium, located at 44th Street and Broadway, was formerly the PlayStation Theater and before that the Best Buy Theater. Left, the venue sign in 2015, and below, in 2022.

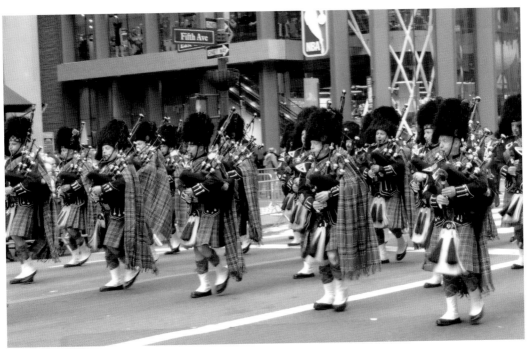

New York City's many annual parades are a colorful and musical celebration of a variety of holidays and cultures. The St. Patrick's Day Parade, seen here in 2016, is known for its marching bands and bagpipe music.

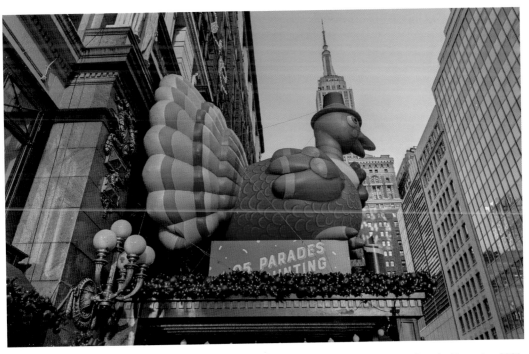

An inflated turkey atop the Macy's marquee on 34th Street for the Thanksgiving Day Parade, November 2021. The parade, broadcast nationwide from 9 am to noon Eastern Time, features numerous musical and dance numbers performed in front of the landmark department store. The parade attracts about 25 million television viewers and three million in-person viewers.

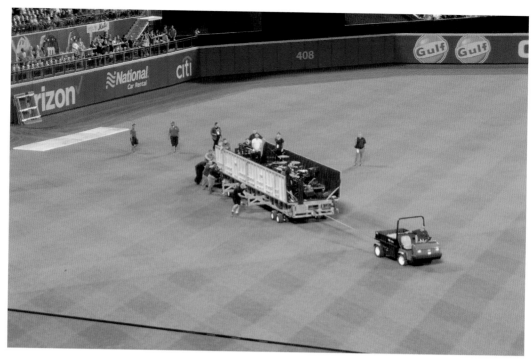

Setting up for a post-game Andy Grammer concert at Citi Field in June 2016. The stage rolled out from the bullpen area and was quickly assembled. Citi Field concerts over the years have included the Steve Miller Band, Dead & Company, Green Day, Lady Gaga, 50 Cent, and Foo Fighters.

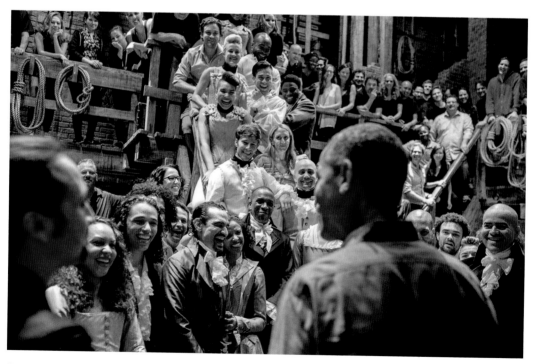

President Barack Obama greets the cast of the hit Broadway musical *Hamilton* at the Richard Rogers Theater in July 2016. The show launched its New York-born creator, Linn-Manuel Miranda, into superstardom.

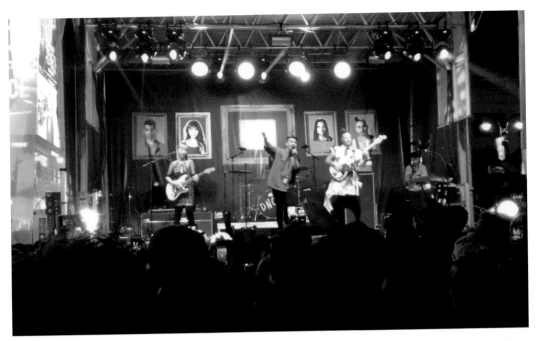

The pop group DNCE (fronted by Joe Jonas of the Jonas Brothers) performs in a pop-up concert in front of Penn Station in November 2016. Musical surprises such as this are treats for those lucky New Yorkers who happen to be in the right place at the right time.

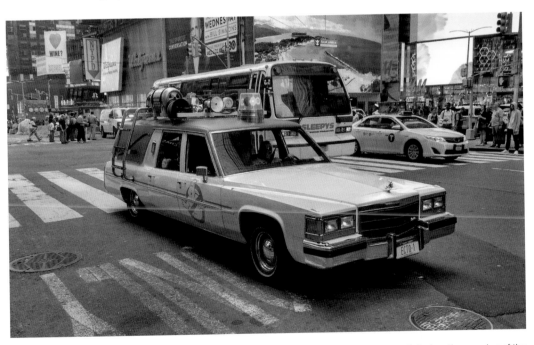

The Ecto-1 Ghostbusters Cadillac hearse drives the streets of New York City a month before the opening of the 2016 reboot of the movie, starring a female cast of paranormal investigators. The *Ghostbusters* movies were famous for taking place in New York, at several well-known sites including the New York Public Library. The theme song (by Ray Parker, Jr.) from the movie spent three weeks at Number 1 on the Billboard charts in 1984, when the original movie came out.

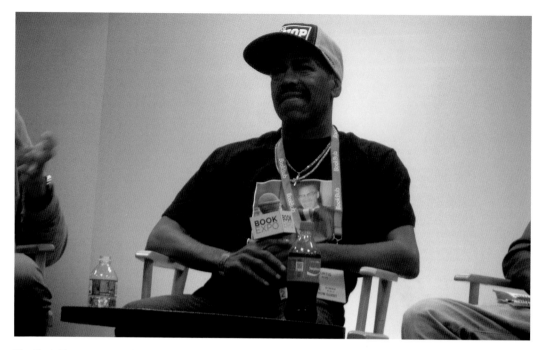

The Book Expo, an annual industry event that often took place in New York City at the Javits Center, usually featured at least a couple of big-name musicians every year who either appeared as panelists discussing music-related topics or to promote their own autobiographies or works of fiction. In this image from the 2018 Book Expo, rap pioneer Kurtis Blow (*The Breaks*) addresses the audience.

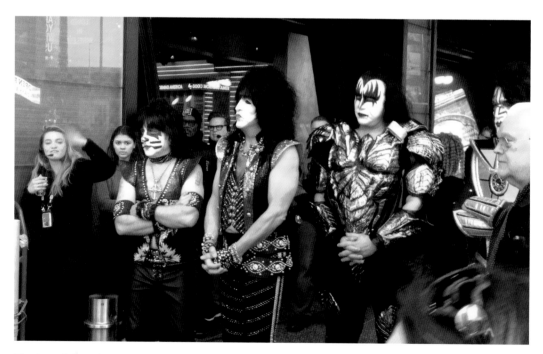

Members of the rock group Kiss (formed in New York City in 1973) pose in front of the *Good Morning America* studios in Times Square in 2018. The morning television show has hosted numerous musical guests over the years, some visiting to talk about books or special projects and others to perform on live TV.

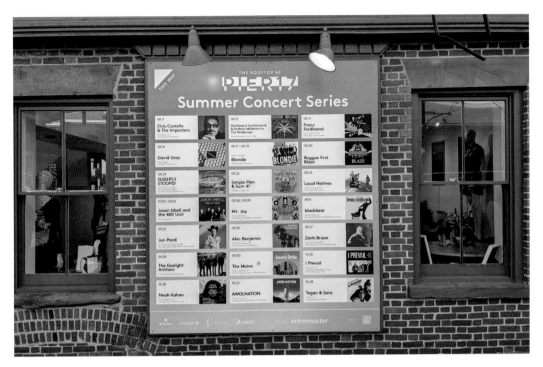

A poster on Fulton Street at South Street Seaport advertises the 2022 season's concert schedule at the Seaport's Pier 17 venue. Pier 17 opened in 2018 and hosts numerous events on its rooftop, offering great views of Lower Manhattan and the Brooklyn Bridge.

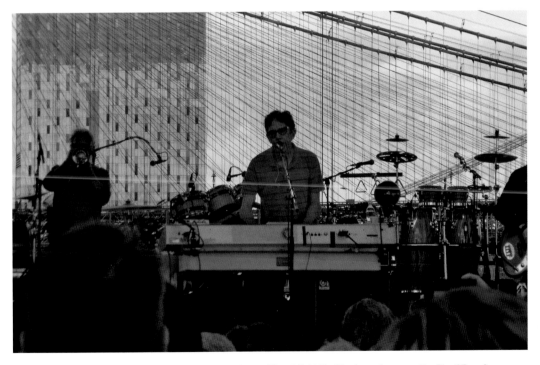

Alternative rock band and New York City mainstay They Might Be Giants performs on the Pier 17 rooftop venue at South Street Seaport in August 2019; the cables of the Brooklyn Bridge form a unique backdrop.

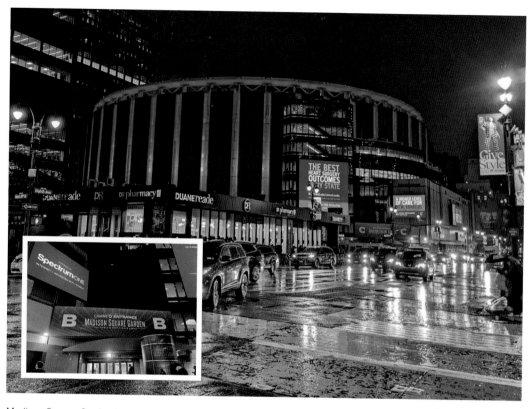

Madison Square Garden is one of the country's best-known venues. In addition to hosting professional sports teams, it has been an arena where some of the most legendary acts have performed, including Elvis Presley, the Rolling Stones, The Who, Bruce Springsteen, John Lennon, Billie Eilish, and Elton John.

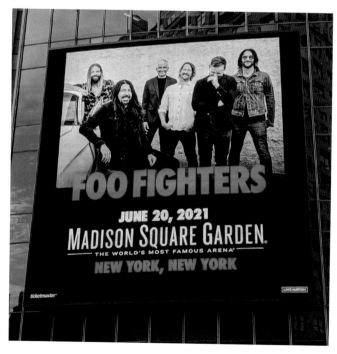

An advertisement for a Foo Fighters concert at Madison Square Garden in June 2021. It would be the first concert at the famous venue since the start of the pandemic in March 2020.

On September 10, 2021, the 40th anniversary of MTV (which first broadcast on August 1, 1981; "Video Killed the Radio Star" by The Buggles was the first video shown) was celebrated in Times Square, near the MTV studios at 1515 Broadway. Their mascot, an astronaut on the moon, signifies the network reaching uncharted territory with their music video programming. MTV Studios has been at 1515 Broadway since 1997. The building also houses the Minskoff Theater, which has been the home of the popular musical *The Lion King* since 2006.

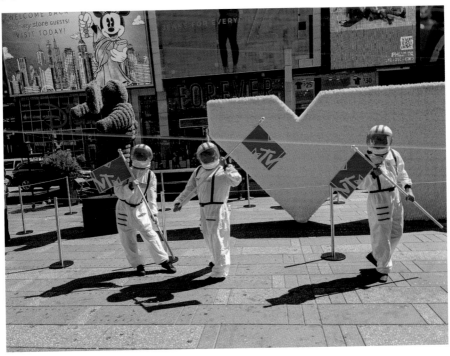

A Times Square festival on September 17, 2021, celebrates the return of Broadway shows after a year and a half hiatus due to the Covid-19 pandemic. In this image, a pianist entertains a crowd gathered at lunchtime with some showtunes.

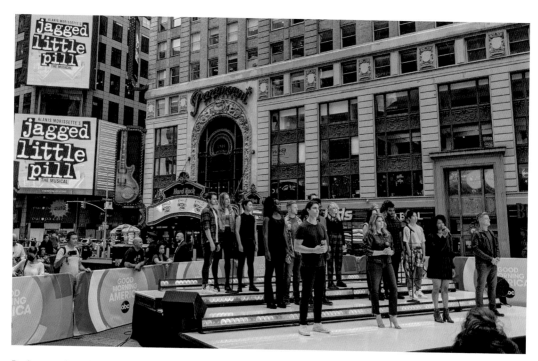

Performers from the Broadway musical *Jagged Little Pill*, based on the life of and written by singer Alanis Morrisette, perform pieces of songs from the show in front of the *Good Morning America* television studios in September 2021.

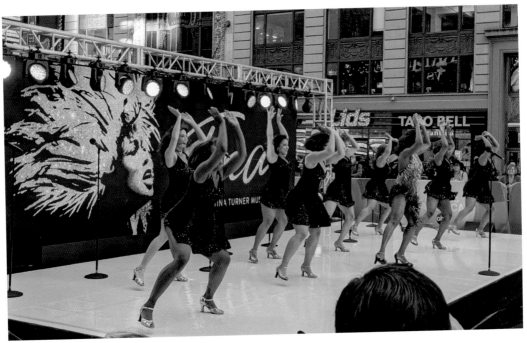

There are ordinary Broadway musicals, and then there are Broadway musicals about musicians, of which there have been several in recent years. Some examples include: *A Beautiful Noise: The Neil Diamond Musical*, *MJ: The Musical*, and *Ain't Too Proud: The Life and Times of the Temptations*. Shown here, dancers perform a number from *Tina – the Tina Turner Musical* in Times Square, October 2021.

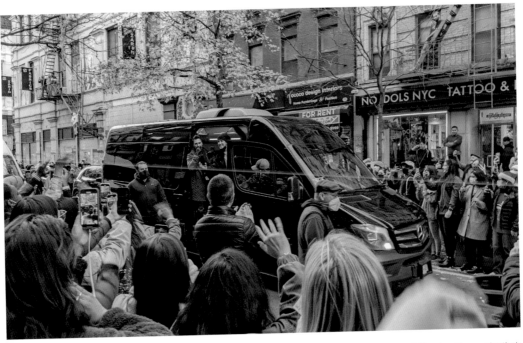

Members of the pop band Big Time Rush wave to hundreds of fans lined up on Orchard Street as they make their way to a December 2021 appearance at the Laams store for a meet and greet in celebration of their reunion, new album, and concert tour.

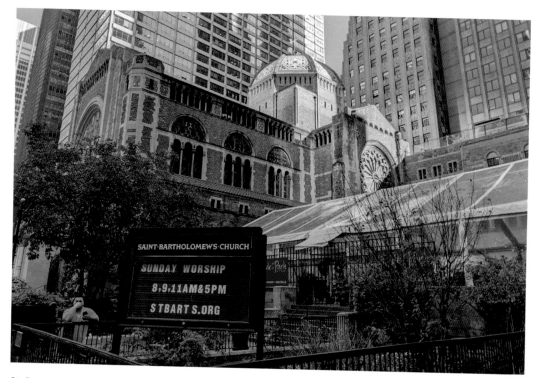

St. Bartholomew's Church (1918; parish founded 1835) on Park Avenue between 50th and 51st Streets, has New York City's largest pipe organ, an Æolian-Skinner type with 12,422 pipes. For those who are unable to go inside the landmark structure, they can still enjoy the church bells if the timing of their visit is right.

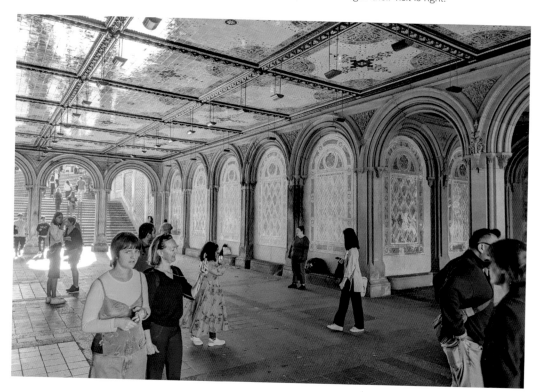

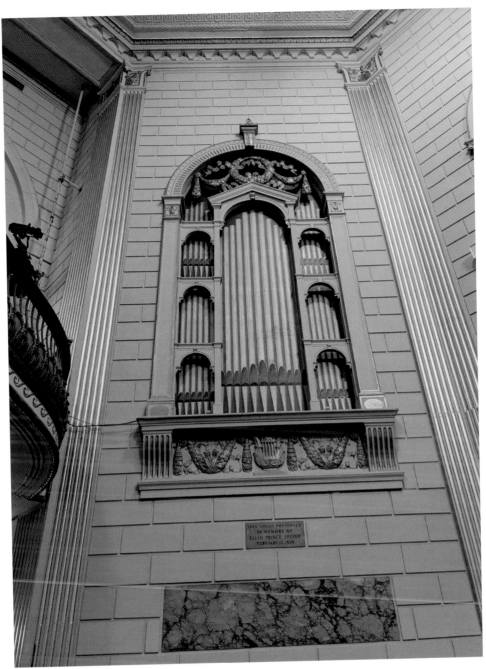

Town Hall is a non-profit music and cultural events venue on West 43rd Street. Founded by suffragists and opened in 1921, it was host to the American debut of Richard Strauss and Isaac Stern and has hosted numerous musical icons over the years, including Dizzy Gillespie, Marian Anderson, and Charlie Parker. This image shows the organ pipes, which date to 1924.

Opposite below: "Street" musicians perform in all corners of the city. The acoustics in the ornate, highly decorated tunnel under Bethesda Terrace in Central Park are excellent, attracting various musicians to sing or play instruments. On this afternoon, a woman sings and her voice echoes beautifully off the walls and ceiling.

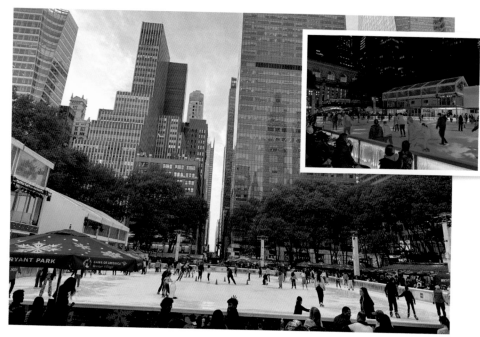

Between November and March, the great lawn at Midtown's Bryant Park is converted to an ice-skating rink, with music playing for the skaters' and spectators' enjoyment. In the summer, the same spot is a converted back to a great lawn with a stage offering concerts. Inset: The Bryant Park skating rink in the evening.

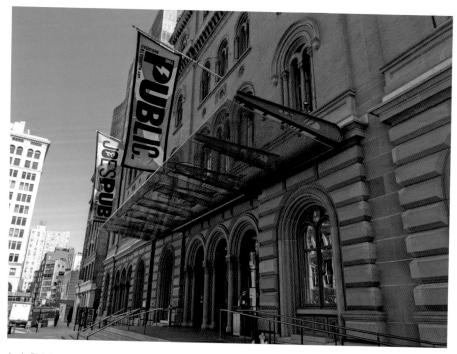

Joe's Pub is a music venue located at the Public Theater on Lafayette Street at Astor Place. In November 2022, the venue was offering *Plays for the Plague Year*, an anthology of songs and plays by Suzan-Lori Parks.

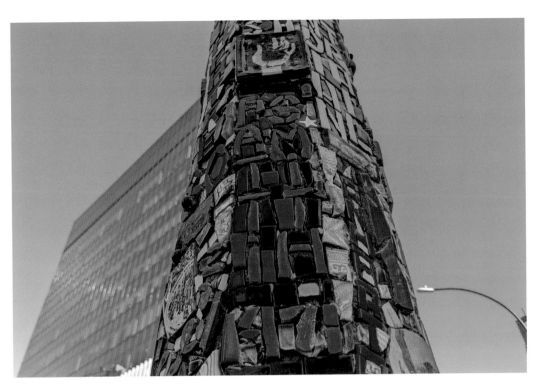

The colorful mosaics on a light pole in Astor Place and in other locations in the city are the work of Jim "Mosaic Man" Power, an Irish immigrant. Construction work on improvements to Astor Place required the mosaics to be removed in 2014, but they were restored in 2016. Among the names on this mosaic pole are musician Patti Smith, the club CBGB, and Donny Records, a popular vendor who set up a table in Cooper Union Square.

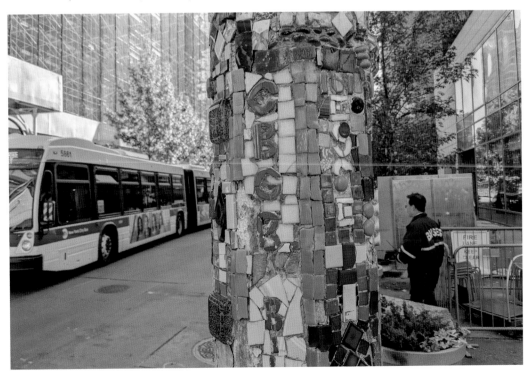

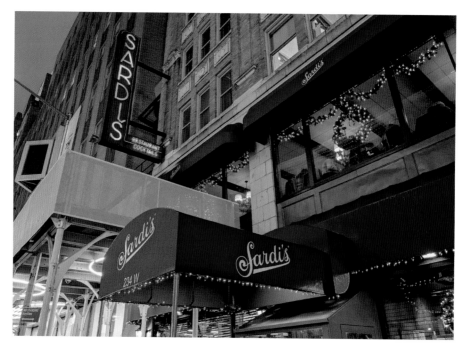

Sardi's is a famous Times Square restaurant that has catered to the Broadway theater crowd as well as celebrities of all kinds for decades. It is the spot where the Tony Awards were conceived in the 1940s. It is also known for its over 1,000 celebrity caricatures hanging on the walls.

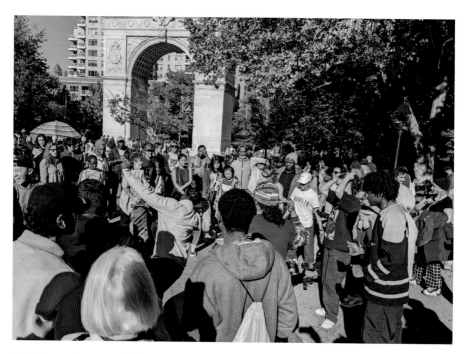

Breakdancers draw a crowd of onlookers on a warm autumn day at Washington Square Park. Breakdancing originated in New York City in the 1970s. The park is a very inspiring and welcoming creative artistic space that is host to and hangout for numerous musicians and performers year-round; the author spotted local resident Ric Ocasek of the Cars in the park in 2016.

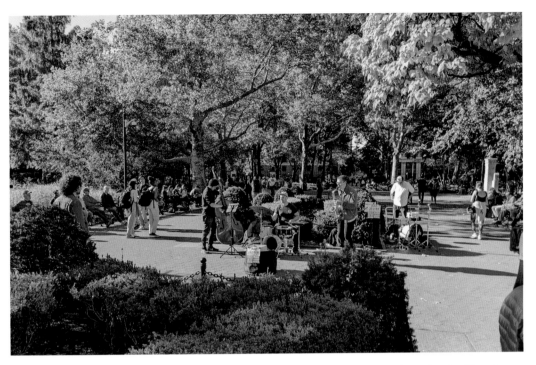

Washington Square Park is large enough that numerous musicians can locate themselves in different areas without competing with each other. Here, a group of performers play in the area just northwest of the fountain.

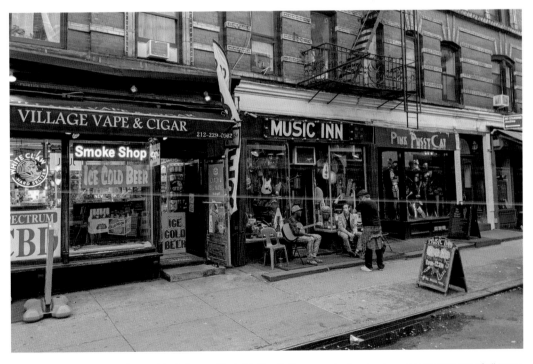

First opened in 1958, the Music Inn on West 4th Street offers an eclectic mix of musical instruments of all types, as well as a repair shop to fix broken instruments and vinyl records. According to their website, they are "a place where different cultures find common ground."

The Greenwich House Music School on Barrow Street opened in 1905 and has provided music education to tens of thousands of students of all ages since then. One notable alumnus is Bobby Lopez, co-writer of the songs in the movie *Frozen* and co-creator of the Broadway musical *The Book of Mormon*.

Flyers for the band Babyllon posted on the Bowery. They describe themselves thusly: "If Amy Winehouse and Led Zeppelin had a baby, this would be the sound." New York is teeming with hundreds of bands of all kinds; each one trying to get traction and gain an audience. Flyers can be found posted on every available surface around the city.

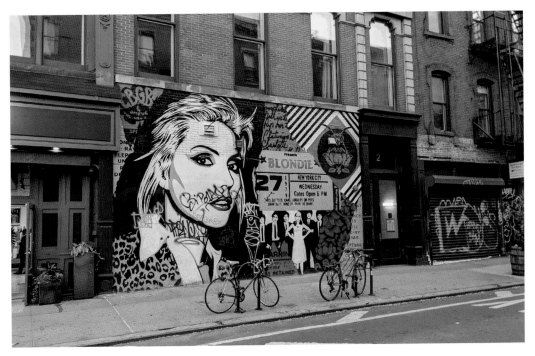

In 2017, a mural of Debbie Harry (lead singer of Blondie) was completed by artist Shepard Fairey across the street from the former site of the famous CBGB club on the Bowery, as a tribute to the venue. Seen in 2022, the mural was restored in 2020 after it had been marred with graffiti.

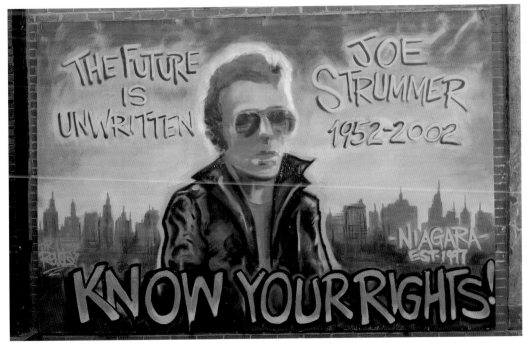

The Joe Strummer mural at the Niagara bar on East Seventh Street and Avenue A was originally painted in 2003, the year after The Clash lead singer's untimely death. The mural had to be removed in 2013 due to the underlying brick wall's instability, but it was repainted shortly after the wall was repaired.

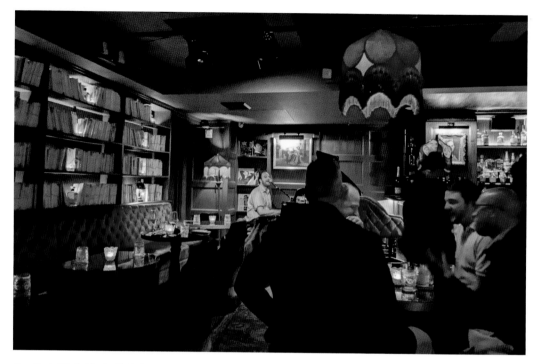

New York City is filled with intimate, sometimes well-hidden speakeasies and bars offering live music. The Bo Peep Highball & Cocktail Store on West 36th Street is one such example. Self-described as a "subterranean piano den" and "Midtown's best kept secret," it offers an intimate underground setting for drinks and live music (five nights a week). Patrons descend stairs to enter a cozy and lushy appointed "secret" red-toned room.

A guitar-shaped cookie on display at the Funny Face Bakery on Fulton Street at South Street Seaport.

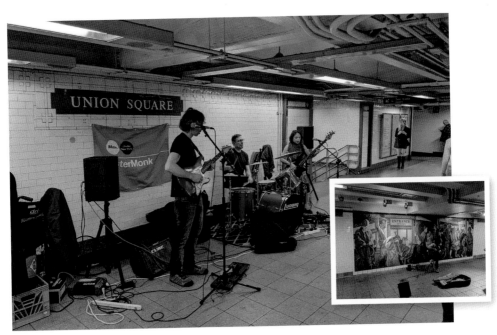

Music Under New York is an MTA-supported program that began in 1985. It offers 350 performers annually at forty locations throughout the subway system. Subway musicians perform in all musical styles and can range from one-person singers to bands with more elaborate setups. Performers have to audition to be accepted into the program. Inset: A guitarist entertains passersby on a November afternoon in the Times Square subway station.

The subway itself is rather musical. The click-clack sound as the cars pass along the tracks has a definite rhythm, and the sound of some IRT trains accelerating was confirmed by engineers in 2009 to inadvertently recreate the opening notes of "Somewhere" from West Side Story (due to the interaction of the propulsion system and the steel rails).

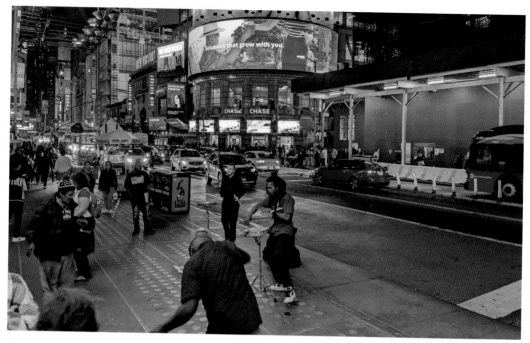

On an evening in Times Square, a pair of percussionists/performance artists play along to Michael Jackson's 1982 hit song "Wanna Be Starting Something," attracting a small crowd of onlookers and soliciting donations from their appreciative audience. With some choreographed drumstick tossing and dramatic flourishes, they hammer out a mesmerizing beat.

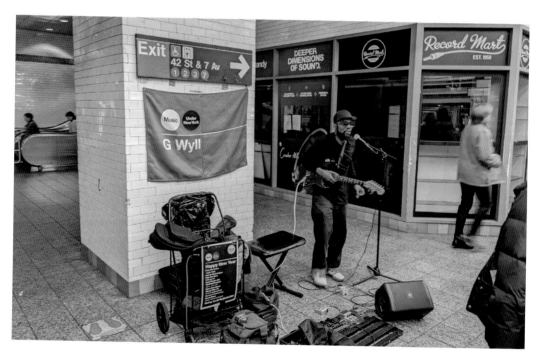

A subway musician performs in Times Square, in front of the retail space that had been occupied by Record Mart, which was the city's oldest record store. Founded in 1958, it closed permanently in 2020 due to the Covid-19 pandemic.

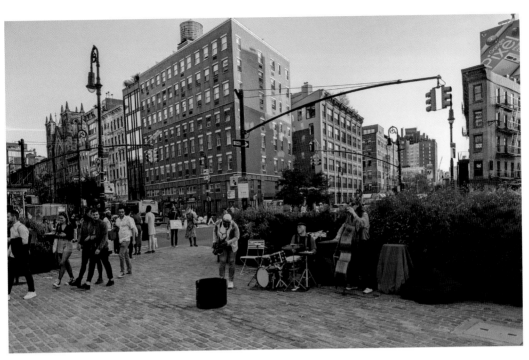

Street musicians can be found all over the city, no matter what time of year or time of day. Here a trio plays in a plaza at the intersection of 14th Street and Ninth Avenue on a Saturday afternoon in November.

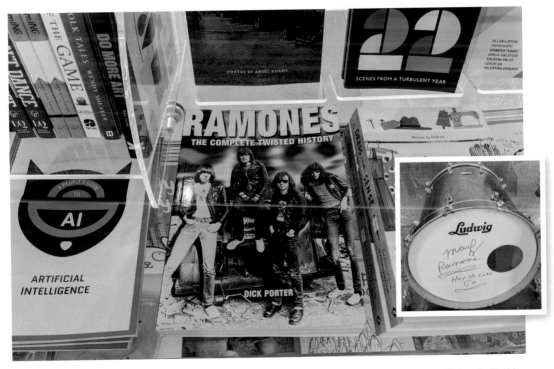

A book about the ubiquitous NYC band The Ramones, on display at the Queens Museum gift shop in Flushing Meadows Corona Park in 2022. Countless musicians got their start in the city. Inset: A drum signed by Marky Ramone on display in the window of the New York Hard Rock Café.

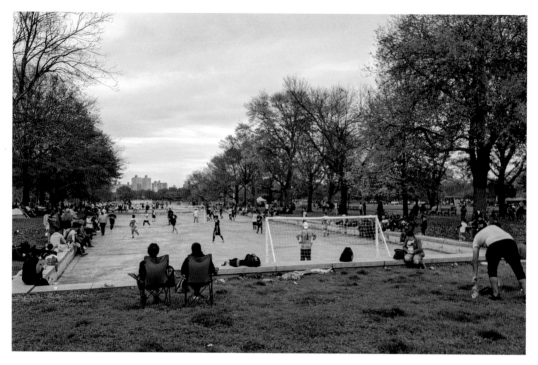

Sports in New York City's parks is often accompanied by music. In this image, soccer players listen to music as they play on a warm autumn day at Flushing Meadows Corona Park.

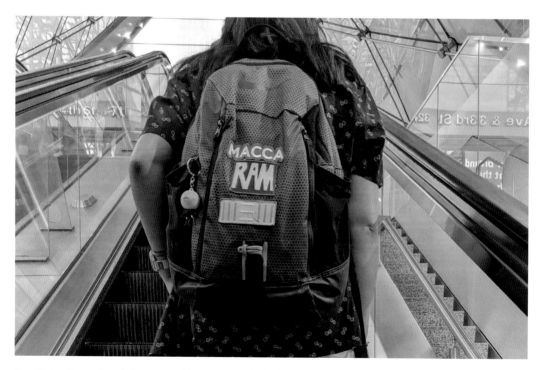

New Yorkers' love of music is expressed in many ways, including on their clothing and accessories. This young woman wears a "Macca" (a nickname for Paul McCartney) patch on her backpack. She also sports patches for two of McCartney's solo albums: *Ram* (1971) and *New* (2013).

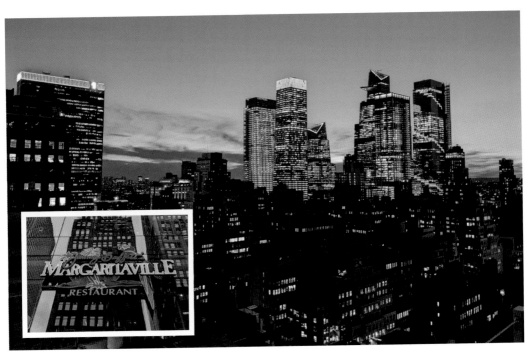

Musician Jimmy Buffet has turned his hit song "Margaritaville" into an entire industry. In 1985, he opened the first of his Margaritaville establishments in Florida. The New York City hotel (with bars and restaurant) opened on West 40th Street in 2021. It features a rooftop bar on the 31st and 32nd floors offering stunning views of the city.

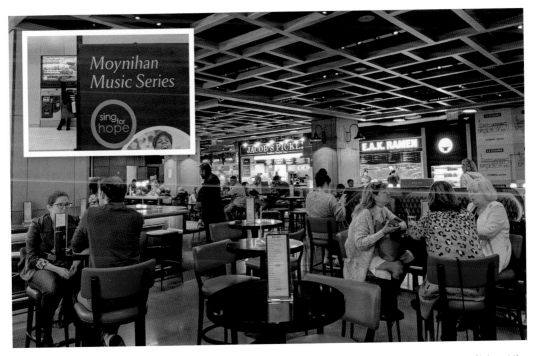

Music is so ubiquitous in New York that you have to really pay attention to realize it is omnipresent. Sitting at the bar in the Moynihan Train Hall on a Saturday evening, music plays in the background as you sip on your drink. Inset: A sign announcing the Moynihan Concert Series in 2023.

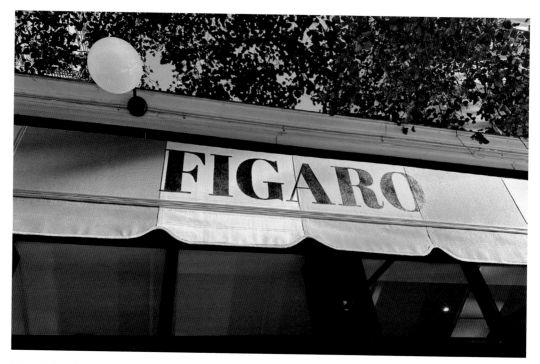

Figaro Café on Macdougal Street was founded in 1957 and was a hangout for musicians such as Bob Dylan and Lou Reed. It closed in 2008, but in 2021, it was modernized and reopened.

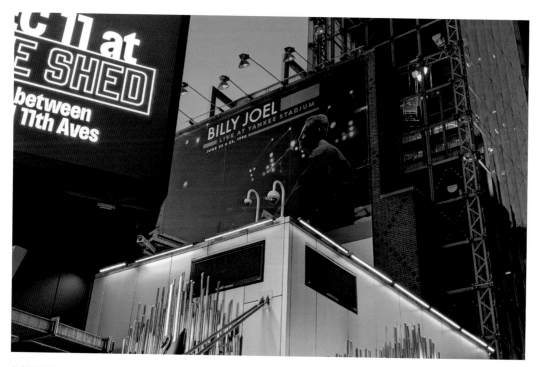

A 2022 billboard on Seventh Avenue and 34th Street advertises a newly remixed twenty-two-song, two-cd/DVD set of Billy Joel's legendary two nights of performances at Yankee Stadium in June 1990. The concert film of those performances is regarded as one of the best such films ever made.

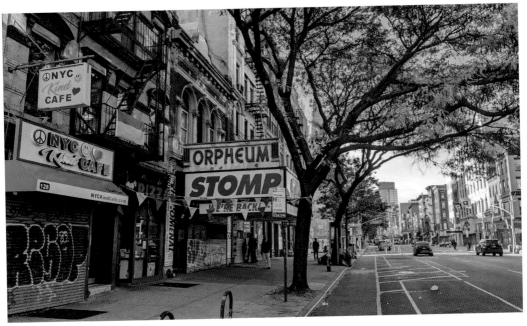

The Orpheum Theater on Second Avenue between East 7th Street and St. Marks Place has been home to the multi-percussionist performance called *Stomp* for decades. The performers use objects such as garbage cans, brooms, and matchboxes to create a musically creative and carefully choreographed show.

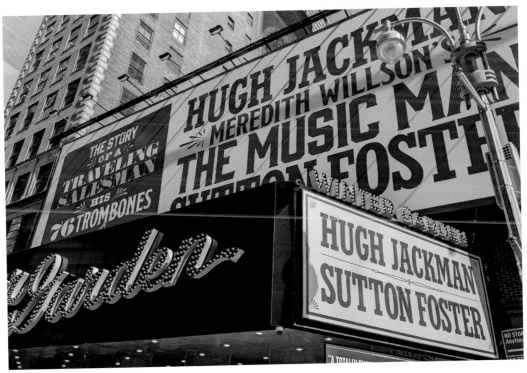

Some of Hollywood's biggest stars wind up on the Broadway stage playing the lead in popular musicals. This 2022 photo shows the marquis for *The Music Man* at the Winter Garden Theater on Broadway and 50th Street, featuring Hugh Jackman and co-star Sutton Foster.

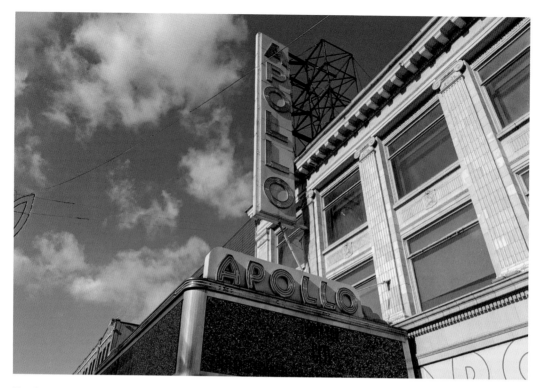

The Apollo Theater, which opened in 1914 on 125th Street in Harlem, has been a noted venue for African-American performers, and is the home of *Showtime at the Apollo*, a nationally syndicated television variety show.

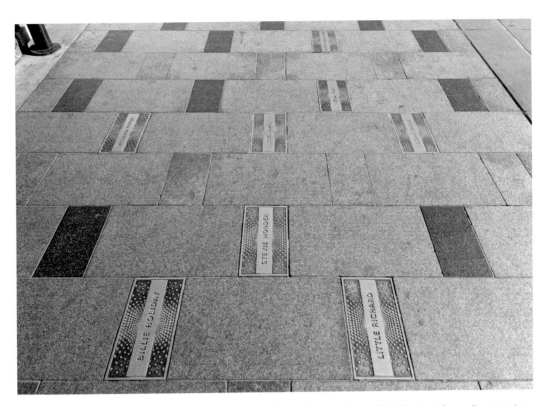

In 2010, the Apollo Theater introduced its Walk of Fame directly in front of the theater, to honor the many jazz, soul, R&B, and pop legends whose careers were started or aided by appearances at the famed theater. The first inductees were Quincy Jones, Patti LaBelle, Smokey Robinson, James Brown, Gladys Knight and the Pips, Little Richard, and Ella Fitzgerald. Since then, many other artists have been added, including Michael Jackson, Patti Labelle, and Prince.

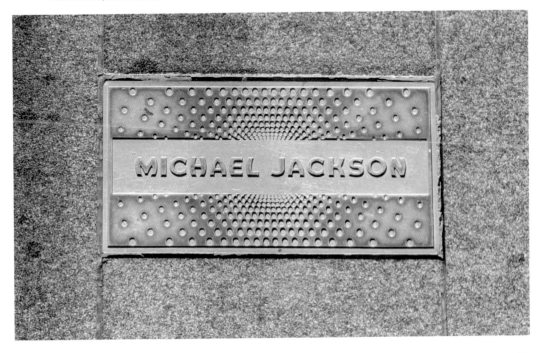

There have been numerous recording studios all over New York, but not all recording spaces were made specifically for that. The Grand Lodge inside the Masonic Hall at 23rd Street and Sixth Avenue (built 1873) has been used as a recording venue by several artists, including jazz musician Wynton Marsalis. In 1984, Joe Jackson and his band recorded the album *Body and Soul* there. Says Jackson's bass player Graham Maby: "I think it was the first time that Joe attempted to record everybody all at once in one space, and they were trying to find a suitable space and they found the masonic lodge. It sounded huge in that room, but it wasn't a very rock and roll atmosphere kind of room, there was a lot of wood and something rather dark and austere about it … but it did sound pretty incredible in there, I appreciated that. We'd cut the tracks and go listen to them, and when you hear the air move like that, there's no denying it."

The Beacon Theater, located on Broadway at 72nd Street is a New York City landmark that was opened in 1929. Over the years, this beautiful venue has hosted some of the biggest names in music history, including The Allman Brothers Band, Sting, the Rolling Stones, Robert Plant and Alison Krauss, and Tom Petty and the Heartbreakers. The Beacon was acquired by Madison Square Garden in 2006; it was restored in 2009.

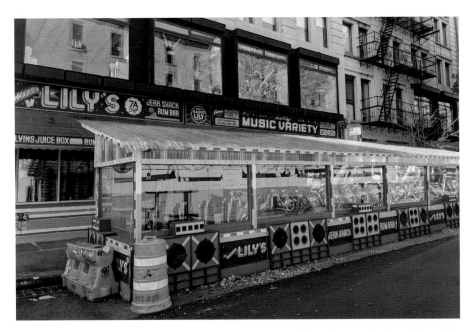

The colorful and visually interesting storefront for Miss Lily's 7A Café on Avenue A at Seventh Street in Greenwich Village. Combination eatery and record store, Miss Lily's offers a unique island-type environment.

A sophisticated new LED light system was installed at the Empire State Building in 2012, capable of achieving 16 million different colors and several special effects. There are six distinct components of the tower that are lit (from the top down): the antenna, halo, top, fins, middle, and bottom. In March 2020, a nightly music-to-light show launched at the Empire State Building to keep NYC bright during the start of the pandemic, featuring Alicia Keys' song "New York State of Mind." During the Christmas holidays of 2020, a similar music-to-light show happened featuring Carrie Underwood. In October 2021, a special light show celebrated Coldplay's "Music of the Spheres" World Tour. During Christmas Week 2021, a light show was set to Ed Sheeran's song "Merry Christmas." Seen here a colorful moment on a November night in 2022.

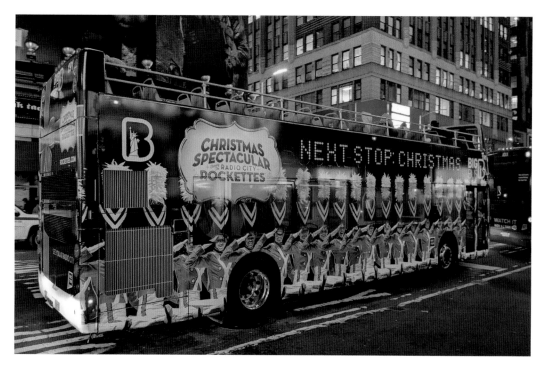

A tour bus on a midtown street in late November 2022 features a wrap advertising the annual Rockettes Christmas show at Radio City Music Hall. The world-famous dance performers had their beginnings in 1925 as the Missouri Rockets, who would soon after become a New York fixture.

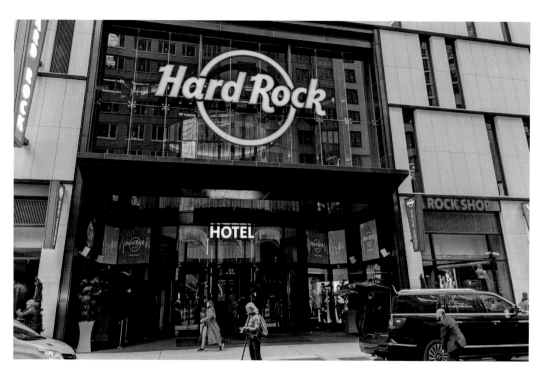

In 2022, the 446-room Hard Rock Hotel opened on West 48th Street, on what was once known as Music Row for its music shops and recording studios. The hotel also contains an event space called the Venue on Music Row.

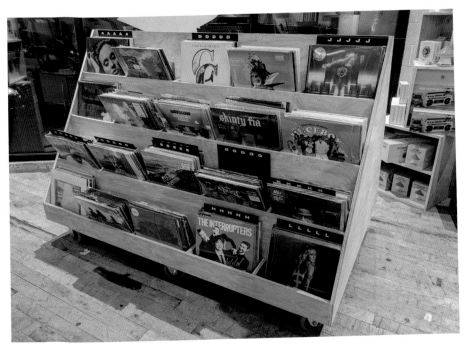

Record stores used to be found all across the city. With the advent of online shopping and the decline of vinyl, many smaller record stores vanished. Bigger ones like the Virgin Megastore sold much more than just music. The Virgin Megastore in Times Square closed in 2009. These days, vinyl is making a big comeback, and record stores are thriving again. This image shows a rack of records in an Urban Outfitters store in 2022.

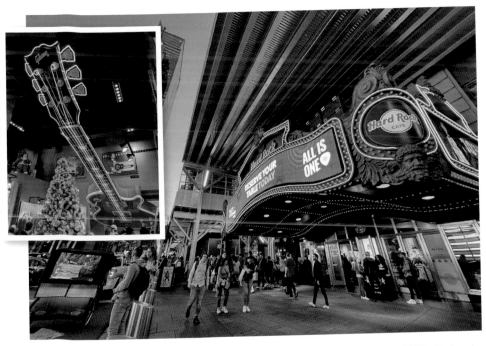

The Hard Rock Café moved to its current location at 1501 Broadway (43rd Street) in 2005, after twenty-one years on 57th Street. Inset: Inside the Hard Rock gift shop, December 2022.

Listen, and you will hear it: the beat of New York City.

It's everywhere you go! From the subways to the streets, from parks to bars, from churches to concert halls. Music in all its glorious forms, sometimes sublime and sometimes spectacular, is a vital part of city life and has been for centuries. Whether a pair of dueling drummers on 42nd Street or break-dancers in Washington Square Park, a mural in the Village or a memorial to John Lennon—New Yorkers celebrate their musical heritage every day in so many ways. So many of the country's best-known musicians have lived or played in New York over the years. Come along on this visual journey through time and catch a glimpse at some of the people and places who have contributed to the Beat of New York.

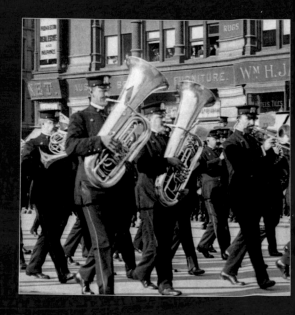

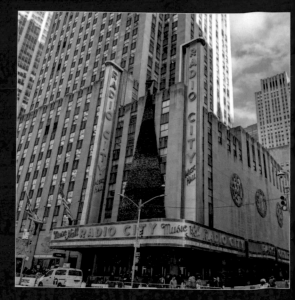

AMERICA THROUGH TIME®

$24.99

ISBN: 978-1-63499-470-5

9 781634 994705 52499

AMERICA
THROUGH TIME®
ADDING COLOR TO AMERICAN HISTORY

www.through-time.com

Connect with us:
f AmericaThroughTime
y USAThroughTime
○ AmericaThroughTime

AMERICA THROUGH TIME® and Adding Color to American History™ are registered and/or unregistered trademarks of Fonthill Media LLC